LOWESTOFT
TO
SOUTHWOLD

LOWESTOFT
TO
SOUTHWOLD

Compiled by
Humphrey Phelps

AMBERLEY

First published 1994
This edition published 2008

Amberley Publishing
Cirencester Road, Chalford
Stroud, Gloucestershire, GL6 8PE

www.amberley-books.com

British Library Cataloguing in Publication Data.
A catalogue record for this book is available from the British Library.

ISBN 978-1-84868-246-7

Typesetting and origination by Amberley Publishing
Printed and bound in Great Britain

Contents

Introduction

Many of the photographs in this book were taken when the fishing industry was at the height of its prosperity at Lowestoft and Southwold, the days of bustling harbours and busy markets, when every autumn hundreds of Scots girls came for the herring season. Gutting and packing herrings, they worked in the open air all day long and sometimes through the night. They and the men who caught the fish richly deserve our admiration. So do those valiant men who manned (and still man) the lifeboats, especially those who set out in stormy seas in lifeboats powered by oars.

The days that these people saw, the life they lived and the hardships they endured, the camera has recorded many of these scenes which we can now see without experiencing the hardship, thus making us long for the days that are no more. And how can we resist longing for those days, when we look at these photographs and realise how much has been lost? How busy and vital those communities now seem, and how long ago; yet in reality not many years have passed between then and now. The vanished Southwold Railway now seems more like an idyllic dream than a solid reality which did useful service for half a century. Fortunately, the camera has recorded plenty of scenes of that delightful railway. And the bathing huts on the beaches; the steamers; the . . . but turn the following pages and see for yourself. And give thanks to all those photographers of yesteryear and to the people who have saved the photographs.

In that delightful book, *Suffolk Scene*, first published in 1939, Julian Tennyson said the real glory of Suffolk is the coast, this most vulnerable of coasts, constantly being devoured by an ever-hungry sea. A sea both savage and benign, taking land and buildings, and lives too; yet a sea that has provided livelihood for many, prosperity for some, and has formed the character of these people born of the East Wind. Seen in that morning light which only reaches such perfection on this coast, who could disagree, no matter how glorious the rest of the county? Of course, it has changed — change is the one constant factor in all things — but it has been changed as much or more by nature than by man, neither of whom has robbed the coast of its beauty.

Julian Tennyson thought about the vandalisms and excrescence of so much of the south coast, 'of the profits that certain sharp-witted gentlemen have enjoyed from them, of the sporadic struggle to stem the tide of disfigurement, of the carelessness and apathy that encouraged it.' The hand of man, he said, 'becomes daily more insidious. There seems no limit to the damage it can do. But the changes it has wrought upon the Suffolk shores are negligible; had it not been for the intractable marshes, the contortions of the rivers, the impossible lay-out of the country, I might be writing a different story. As it is the hand is stayed at almost every turn; it can creep inland, perhaps, if it picks its way with care, but along the shore it cannot stray very far, not with all its ruthless artifice.'

Since 1939 man has devised more 'ruthless artifice', much more ruthless. Man has become greedier, and has not hesitated to use that ruthless artifice. It is only necessary to go inland a few miles and see what has happened to so much of Suffolk, to see what some 'sharp-witted gentlemen' with the aid of government grants have done to the fair face of the county. Woodlands and wetlands, trees, hedges and ancient meadows have been destroyed, the love and labour of generations have been destroyed. Field after field have been joined together making large tracts of Suffolk into prairies. But on and near the coast the havoc wrought by man is negligible. As Julian Tennyson wrote, 'the Suffolk coast, by its very nature, is its own saviour'.

The way of life, however, has changed. Fishing does not dominate the scene everywhere, as it did when most of these photographs were taken. After harvest, ploughing and planting, many farm-workers worked on the fishing boats during the autumn and winter months and they were known as 'half and halfers'. Today you will not find many fishermen in the cottages, Scots girls, ships being built at Lowestoft, or hear the Suffolk accent wherever you are. Times have changed and its not only that people have changed, a lot of them are not even Suffolk people. In the main, apart from a few exceptions, the coast has saved itself better than it has saved its people.

The photographs here are arranged so that they take us on a journey from Lowestoft to Southwold by way of Pakefield, Kessingland, Wrentham, Wangford, and Reydon. They also, of course, take us back as far as the end of the last century. However, at a guess, I think that the first ten years of this century is the decade which is the best represented. As far as dates go there is no logical system, later photographs frequently precede earlier ones. The coverage is not comprehensive and was not meant to be, some of the photographs will have been seen before, but I hope there are some which are new to most people.

In my other books I felt constrained to state that I do not belong to Suffolk although Suffolk claimed may heart many years ago. Of a previous book a kindly reviewer wondered what was my connection with Suffolk. First, as I've just said, I fell in love with the county, it must have been more than fifty years ago. It was not love at first sight, I had not even seen Suffolk then, but through reading the books by Adrian Bell. Then I fell in love with Red Poll cattle whose home was Suffolk and it was these beautiful animals which drew me there when I started a herd of them on my farm. To say I was enchanted by Suffolk is an understatement. In those days, forty years ago, farming had not become industrialised; it was still human, groups of men, Suffolk Horses and Red Polls could still be seen in the fields and there were still plenty of small farms. Yet, despite the changes, much of the beauty and charm remains, together with its houses, the high skies and the luminous light. As Adrian Bell once said, 'the immensity of morning light cannot be had anywhere but on the East Coast'. I have been drawn to these delights ever since.

So, to excuse what may be presumptuous on my part in writing about Suffolk — and it is a charge I will not deny — and to answer that reviewer's question, I can only say, in the woods of the song, love is my reason. Personally, I can think of no better reason.

Some Suffolk friends have been of inestimable value in helping me with this book, by lending me their treasured photographs and by giving me all sorts of information. To Philip Kett, David Moyse, Derrick Neave, John Tooke and Bob Wright, I tender my heartfelt thanks. Without them this book could not have been compiled. If it has any value it is due to them, but any faults are entirely my own work.

Humphrey Phelps

One

Lowestoft

'The Town of the Rising Sun.'

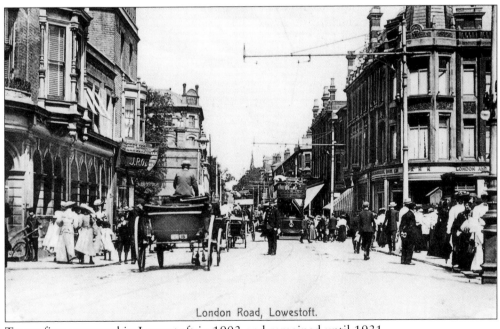

London Road, Lowestoft.

Trams first appeared in Lowestoft in 1903 and remained until 1931.

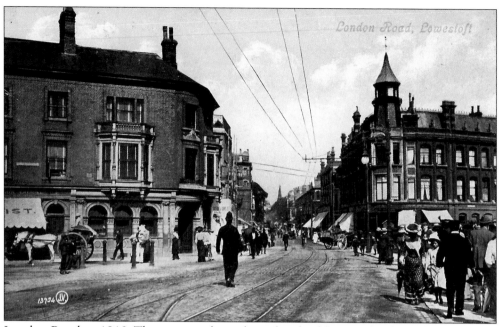

London Road, *c.* 1910. The tram tracks and overhead cables are clearly visible.

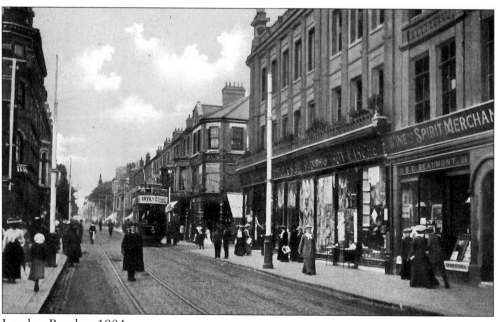

London Road, *c.* 1904.

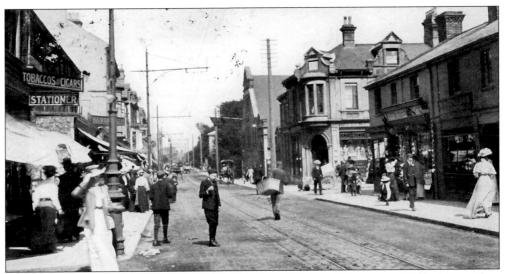

London Road, *c.* 1903. The *Lowestoft Journal and Visitors' List* was published by Arthur Stebbings every Friday from premises in London Road.

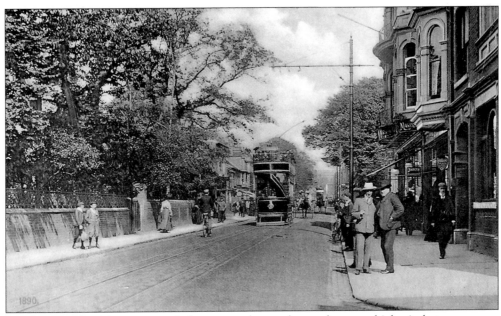

London Road, with two crowded trams and some horse-drawn vehicles in between.

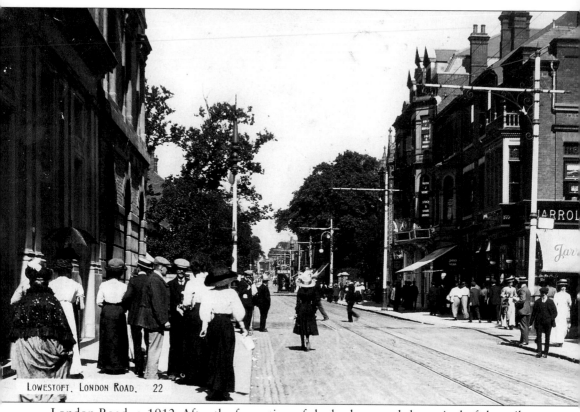

LOWESTOFT, LONDON ROAD. 22

London Road, *c.* 1912. After the formation of the harbour and the arrival of the railway Lowestoft progressed very quickly, and fishing, the town's most notable industry, enjoyed its boom years prior to 1914. The manufactures in the town consisted of rope and twine; sail-making, boat and ship-building and coach-building were also carried on. In addition there were large oil and flour mills.

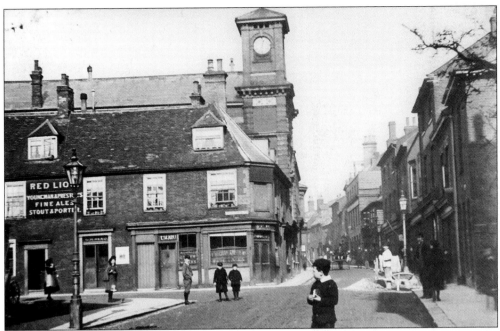

High Street, 1897. The Red Lion, on the left, was demolished *c.* 1901 for an extension of the Town Hall, seen here just behind the Red Lion. Opposite is the Star of Hope, also demolished to make way for the Town Hall. Both public houses were supplied by Youngs and Preston's Eagle Brewery near Rant Score. Note the gas lamp on the left and the road works on the right.

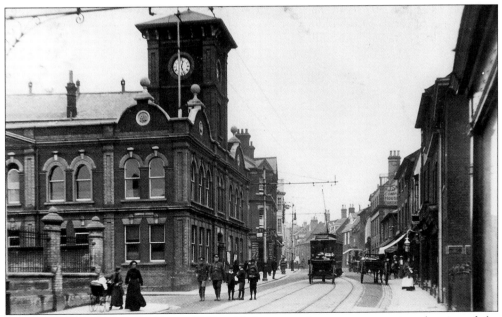

High Street, *c.* 1914. The Town Hall, with its extension now occupying the site of the former Red Lion.

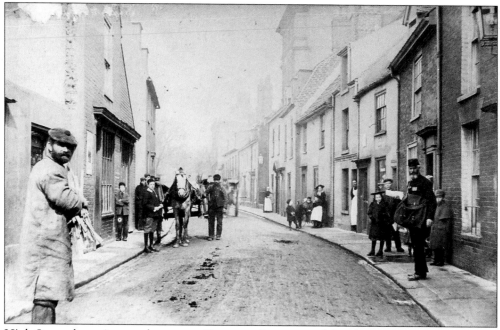

High Street, late nineteenth century. Everyone has stopped for the camera.

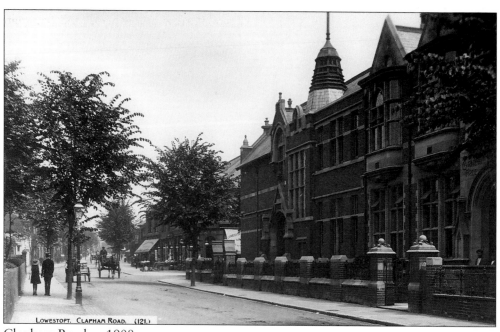

LOWESTOFT. CLAPHAM ROAD. (121.)

Clapham Road, *c.* 1908.

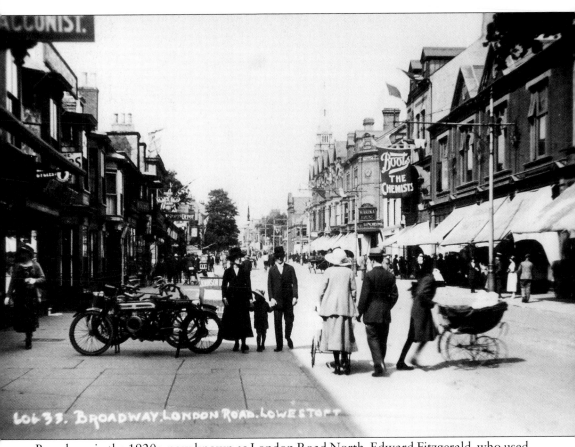

Broadway in the 1920s, now known as London Road North. Edward Fitzgerald, who used to spend some time in Lowestoft, first met George Borrow in Lowestoft, and Benjamin Britten's father was a dentist in the town.

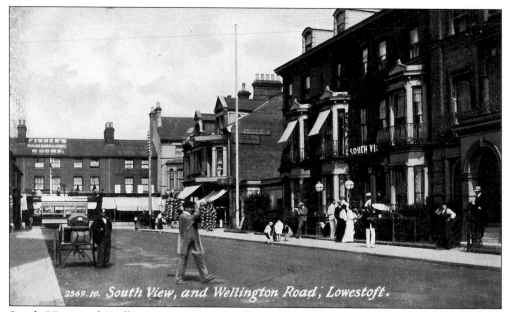

South View and Wellington Road, *c.* 1907, with an onion seller in the centre of the picture.

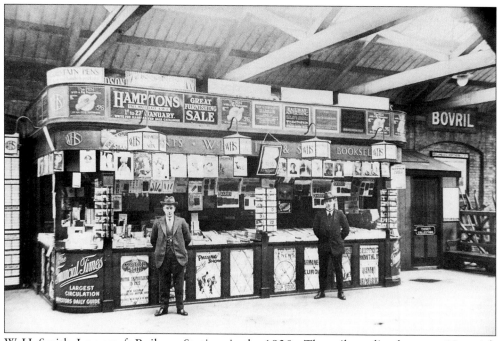

W. H. Smith, Lowestoft Railway Station, in the 1920s. The railway line between Norwich and Lowestoft opened in 1847 and the Lowestoft to Beccles line in 1859.

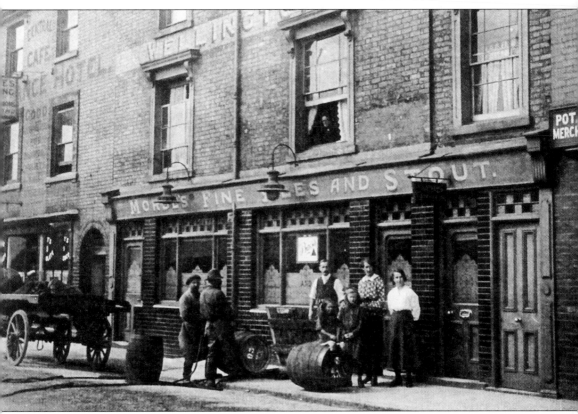

The Duke of Wellington, Commercial Road, *c.* 1900. A barrel of Morse's beer is just about to be lowered into the cellar. E. & G. Morse had the Crown Brewery in Crown Street. Frank Morse was brewing beer in Bell Lane in 1844 at the Bell Lane Brewery but by 1868 the business, now Morse & Woods, had moved to Crown Street. The name Woods was dropped some time during the 1890s. In 1936 the company was taken over by a Norwich Brewery and brewing ceased in Crown Street shortly afterwards.

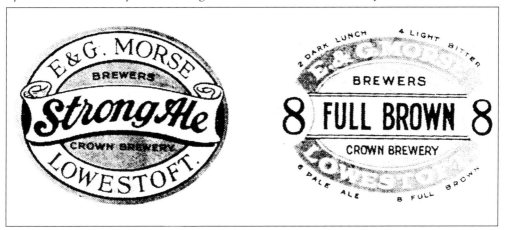

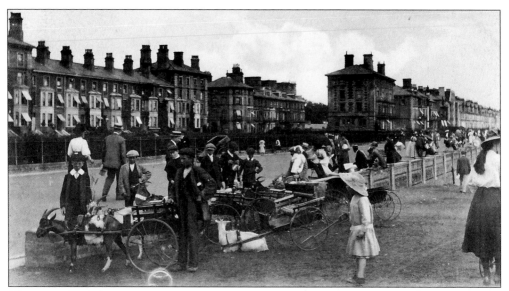

Claremont Parade.

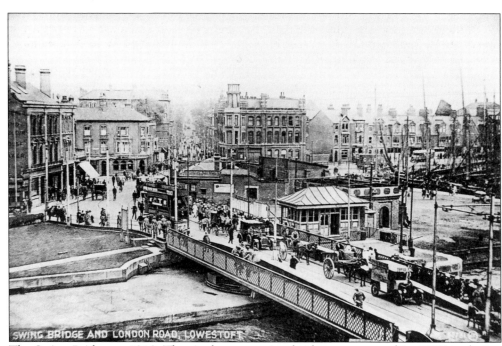

The Swing Bridge, *c.* 1910. The single-span swing bridge was opened in 1897 replacing an older bridge dating from 1830. With the arrival of the trams six years later, overhead equipment was designed to swing with the bridge. The Swing Bridge was replaced in 1972.

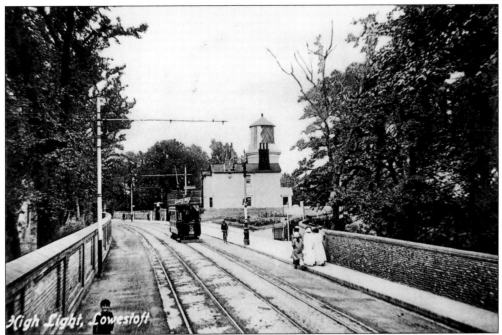

High Street, *c.* 1910. The High Light can be seen in the background. Lowestoft has two Lighthouses, the High Light and the Low Light. The Low Light was built in 1886. It remained in use until 1923 and was demolished soon afterwards. The present High Light was built in 1873 and continued to use oil until 1938. It was still manned during the 1970s but since then it has run automatically. England's first lighthouse was installed at Lowestoft by 1609, Samuel Pepys established a coal-burning light in 1676, a hundred years later it was converted to oil.

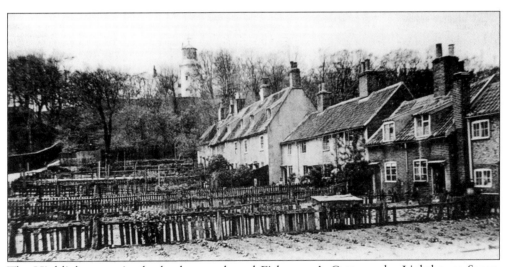

The Highlight, seen in the background, and Fishermen's Cottages by Lighthouse Score, Beach Village. During the Second World War cottages in Beach Village were used to practice house-to-house fighting in preparation for D-Day, and grenades virtually wrecked Beach Village. These cottages have now been demolished.

High Street, *c.* 1906.

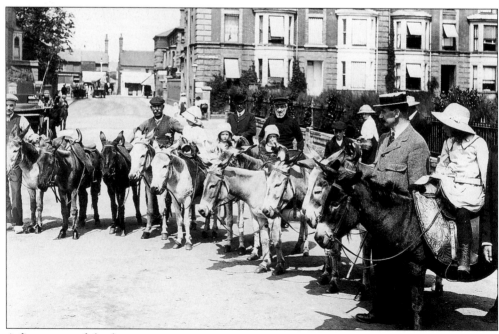

A fine array of donkeys.

Fritten Lake.

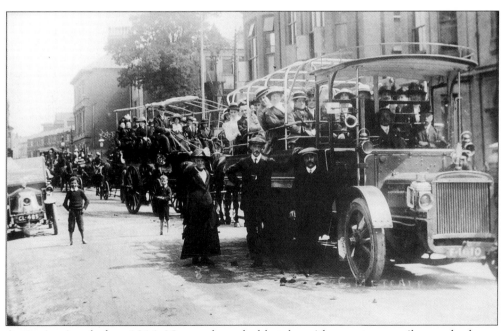

An outing just before 1914. New style and old style, with a motor omnibus and a horse omnibus. Note the stance of the little chap by the motor car as he poses for the camera.

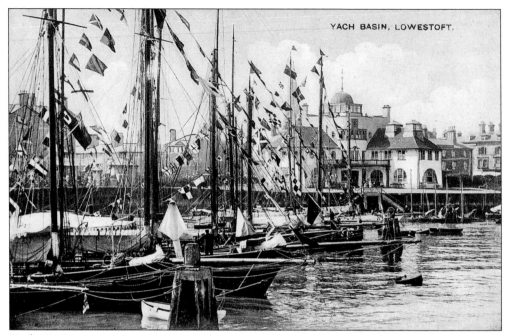

Yacht Basin.

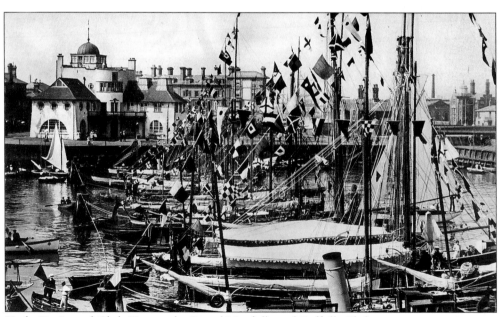

Yacht Basin and Club House, the Royal Norfolk and Suffolk Club.

22

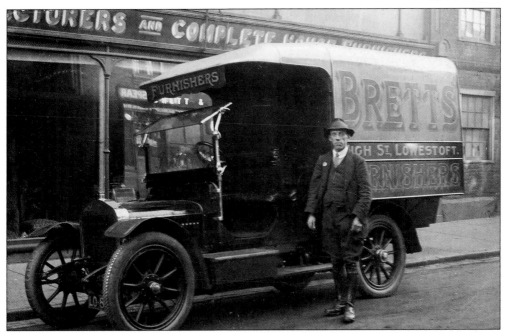

Bretts the Furnishers' delivery van on its rounds, *c.* 1917. Bretts were situated in the High Street.

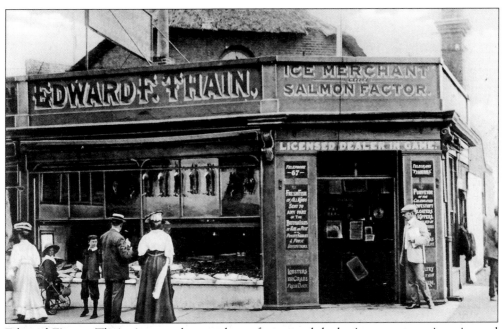

Edward Firman Thain, ice merchant, salmon factor and dealer in game, premises situated at 12 and 13 Trawl Fish Market, *c.* 1905. An ice factory was established in Lowestoft in 1890. Previously most of the ice for the fishing industry had been imported from Norway. A new ice factory was built in 1963 near Hamilton Dock.

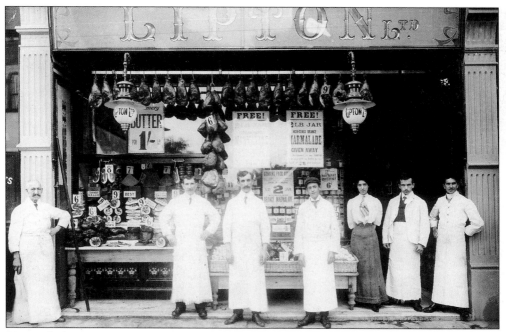

Lipton Ltd.

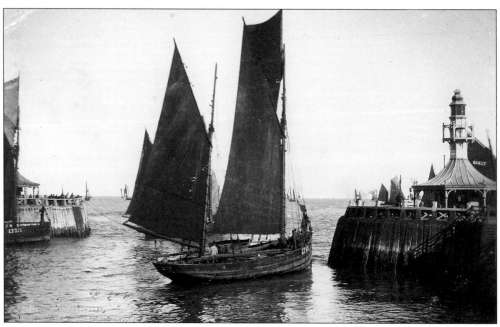

The Harbour, *c.* 1904.

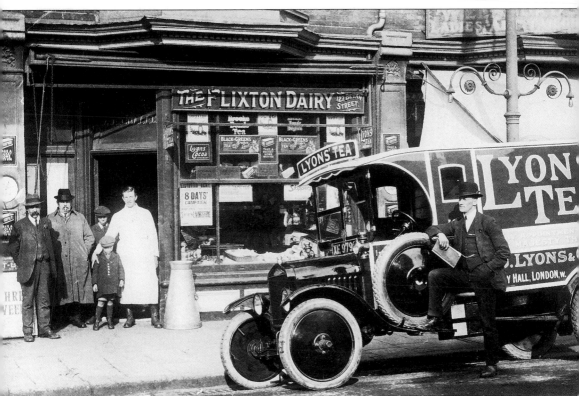

The Flixton Dairy, 127 Bevan Street, and at 128 William Welsford, Tailor. The man by the Lyons' motor van has probably delivered tea to the shop, although this store sold brands other than Lyons. One notice in the window announces an eight-day campaign; the word 'Livingstone' can be seen, but the rest is indistinct. Note the solid tyres on the motor van, the decorative lamp post and the stolid man second from left.

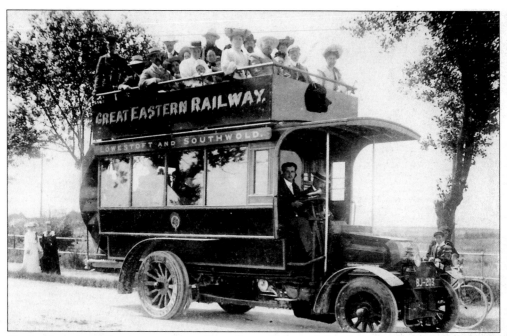

Great Eastern Railway motor omnibus, Lowestoft and Southwold *c.* 1904. Solid tyres again, but look above at the passengers on the top deck. How did the women keep those hats on? The service started in 1904.

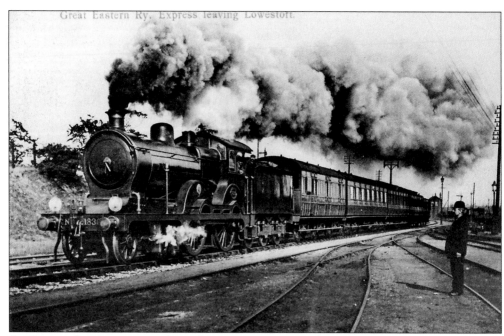

An Express leaving Lowestoft on the Great Eastern Railway.

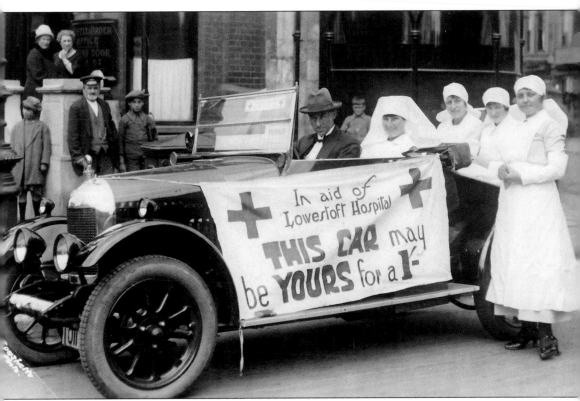

The Lowestoft Hospital was built in 1881-2 at a cost of £7,000.

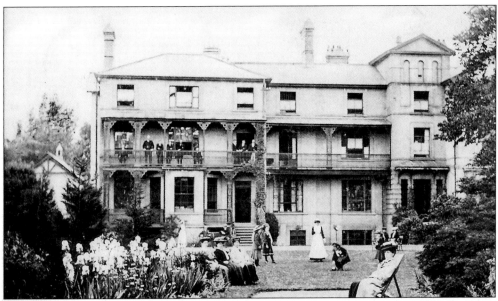

The Convalescent Home near Belle Vue Park, *c.* 1909. The Home was established in 1877 'for persons of either sex likely to be benefited by sea bathing or a temporary residence at the seaside.' Although it was primarily intended for Norwich, East Norfolk and East Suffolk, it was open to patients from other localities.

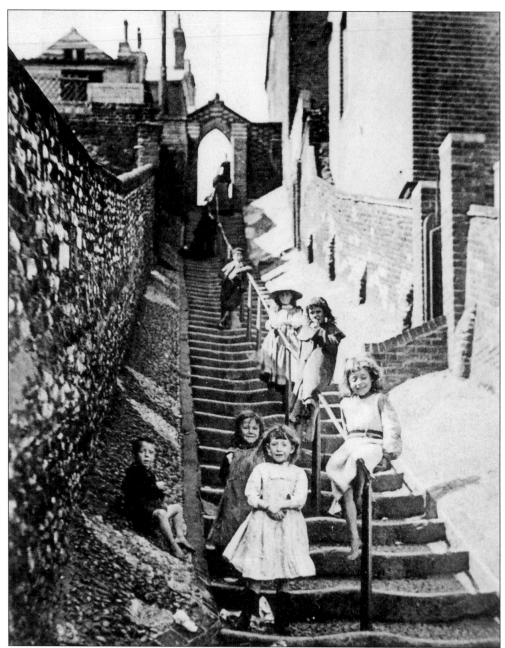

Mariners Score. Lowestoft has several scores. The Lowestoft historian Edward Gillingwater (d. 1813) thought the name derived from 'scored line', another theory was that the word meant 'gangway.' Its most likely source, however, can be seen clearly in this photograph — a score is a cutting down the face of a cliff. The score in this photograph used to be known Swan Score, named after an inn which disappeared during the eighteenth century, and the name was lost soon afterwards. Scots girls who worked in Lowestoft during the herring season used to use the score as a means to get from their lodgings to their place of work at the base of the cliffs. The appearance of many of Lowestoft's scores has changed considerably since these photographs were taken.

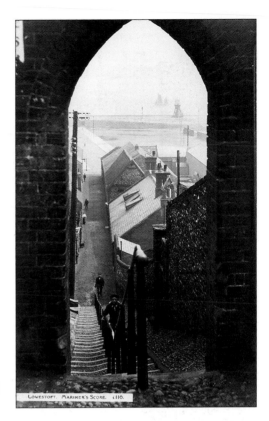

Mariners Score, 1911, looking down at the Low Light. This lighthouse was moved several times.

Lighthouse Score. This score had two hundred cobbled steps with a row of cottages at its foot (see page 19). Among the town's other scores were Spurgeon's, Martins, Herring Fishery, Crown, Rant, and Wilde's. In his Will, John Wilde (d. 1738) left his money to fund the building of a school for forty sons of fishermen where they could be taught 'reading, writing, the costing of accounts and a knowledge of Latin.'

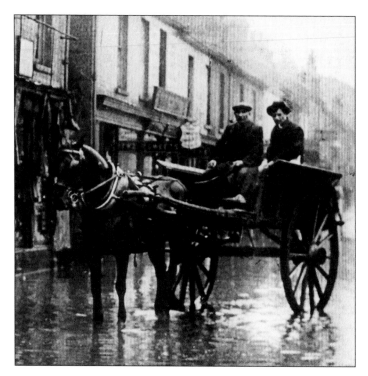

Tonning Street,
29 November 1897.
A tremendous tide
and storm caused
widespread flooding
and damage and many
shipping casualties at
Lowestoft.

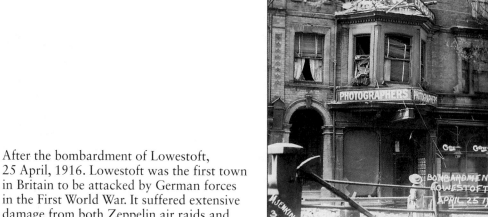

After the bombardment of Lowestoft,
25 April, 1916. Lowestoft was the first town
in Britain to be attacked by German forces
in the First World War. It suffered extensive
damage from both Zeppelin air raids and
shelling from the sea.

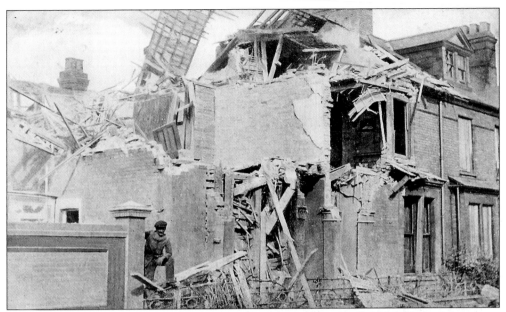

Cleveland Road , North Side after the bombardment of 25 April 1916.

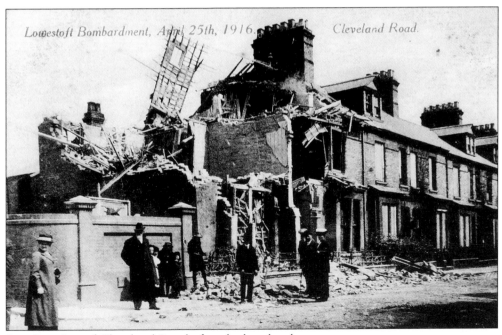

Lowestoft Bombardment, April 25th, 1916. Cleveland Road.

Another view of Cleveland Road after the bombardment.

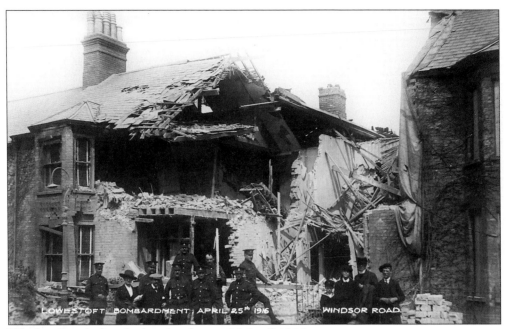

Windsor Road after the bombardment, 25 April 1916.

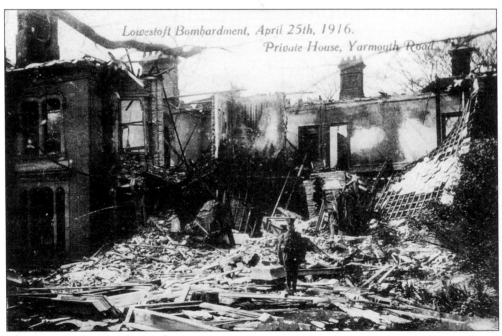

The scene in Yarmouth Road.

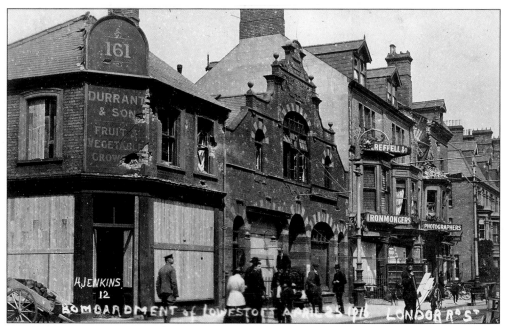

London Road after the bombardment, 25 April 1916.

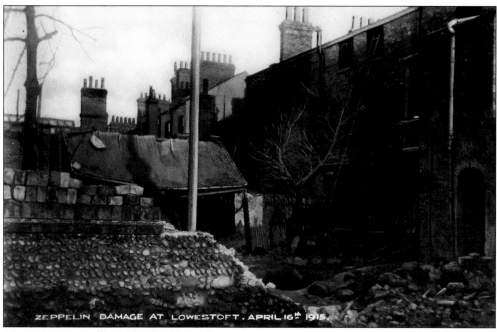

More damage inflicted by the Zeppelin raid on Lowestoft.

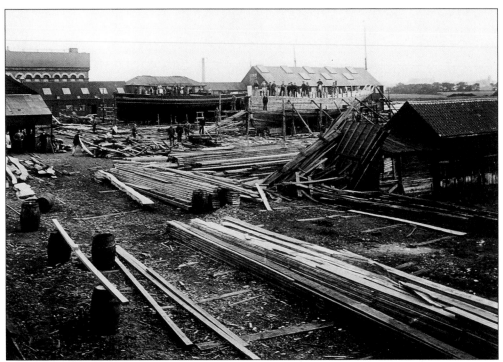

Lowestoft Shipbuilding Yard, *c.* 1900. Ships and fishing boats were built on the beach by the eighteenth century or earlier. John Korff was the first shipbuilder to take advantage of the construction of the harbour. Most of the craft built in the yards were fishing vessels but larger ships were also produced as well as lifeboats.

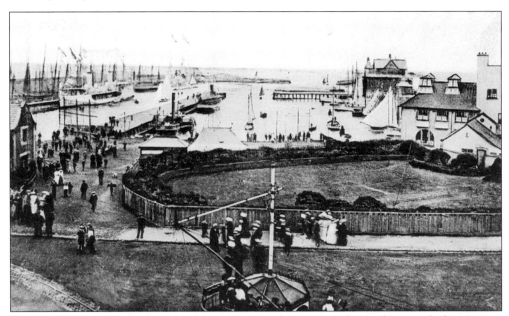

The Harbour and Yacht Basin, *c.* 1922. The beach linking Lake Lothing with the sea was cut through in 1881, thereby creating the harbour. The first dock opened in 1833 and a new dock was opened in 1902.

Two

Pakefield, Kessingland, Wrentham, Wangford, Reydon

'A little of Pakefield succumbs with every winter gale.'

Olive Cook.

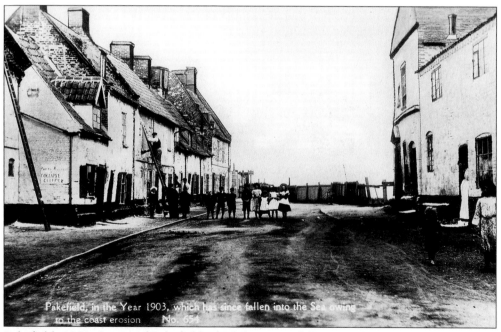

Pakefield, 1903. A part of Pakefield which has since fallen into the sea. 'Their towns and villages crumble about them and go crashing down into the gluttonous waves.' (Julian Tennyson).

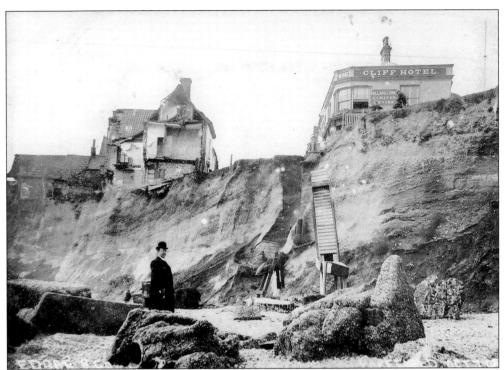

Coastal erosion at Pakefield, October 1905. 'If old Ocean wishes to have a thing he will take it, and at present he is taking Southwold and Pakefield, with other places; also large stretches of marshland are being ruined by the continual advance of the tide along the rivers. But the inhabitants of East Anglia still do little or nothing — or at least nothing concerted. Every man for himself is the cry, and let the sea take the rest.' (Henry Rider Haggard, 27 December 1898).

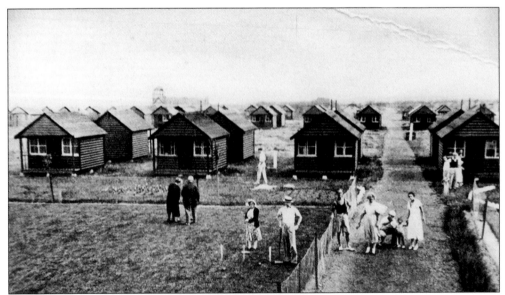

Pakefield Hall Holiday Camp, 1920s (Pontin's Holiday Camp since 1945).

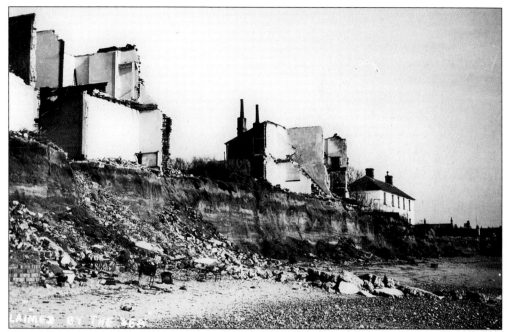

Coastal erosion at Kessingland. Henry Rider Haggard had a house at Kessingland. In 1898 he wrote, 'for here and at Pakefield the high cliff has been taken away by the thousand tons. In such a tide the fierce scour from the north licks the sand cliff and hollows it out till the clay stratum above it falls, and is washed into the ocean.'

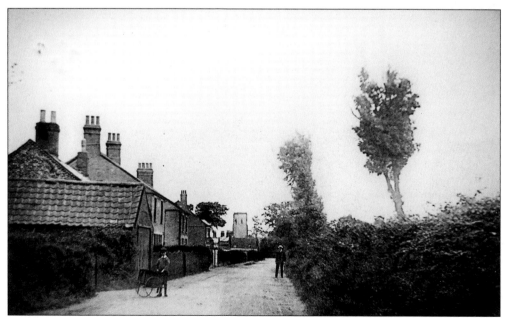

White's Lane, Kessingland.

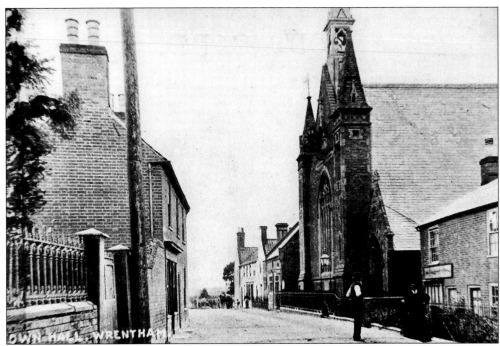

The Town Hall, Wrentham. Wrentham is reputed to be the only village in Suffolk to have a town hall. It still has a Town Band today, but the Hall has since lost its spire and has been turned into living accommodation.

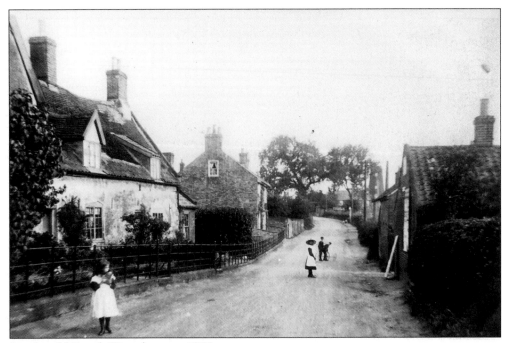

Southwold Road, Wrentham, *c.* 1900.

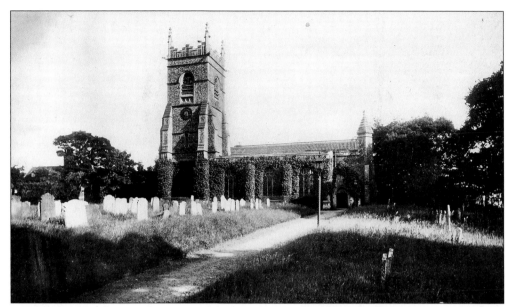

Wangford Church. The Church was restored in 1865 at a cost of £1,500. The chancel and vestry were added in 1875, an organ was installed in 1881 at a cost of £800, and in 1893 a chiming clock at a cost of £120. In 1901 the population of Wangford was 576.

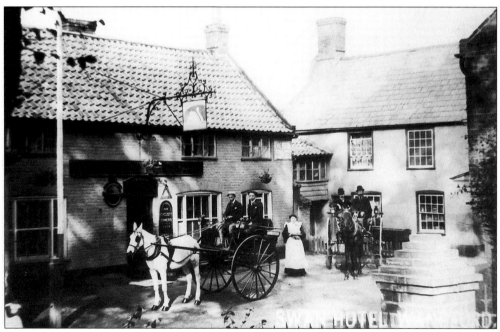

The Wangford Swan, *c.* 1905.

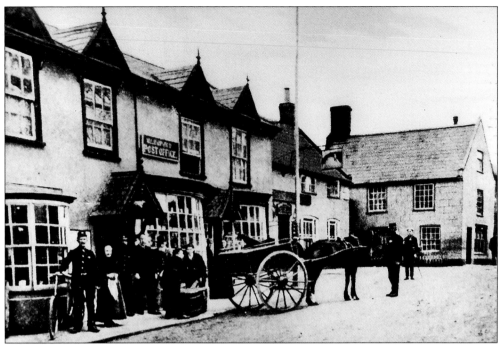

The Post Office, Wangford, in London Road, Wangford's first Post Office premises. Mail arrived via Halesworth at 3.30am and 10.30am.

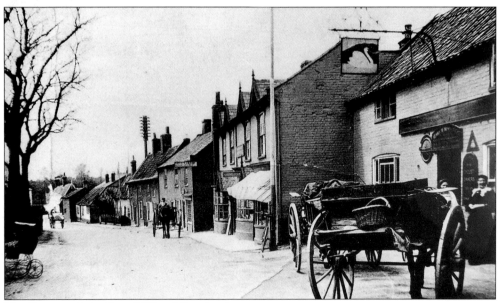

The Swan and the Post Office, Wangford.

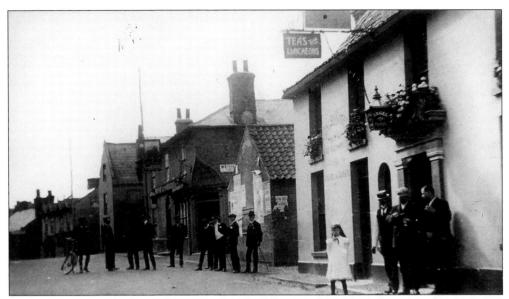

High Street, Wangford, *c*. 1902. The first building on the right is The Angel, which had 'Every accommodation for bicyclists' and for 'staying parties.' Petty Sessions used to be held here on the first Wednesday of every month. The Angel later changed its name to The Poacher. The Lion is two doors away, and around the corner by the tall building stood The Swan.

A motor car accident at Pound Corner, Wangford.

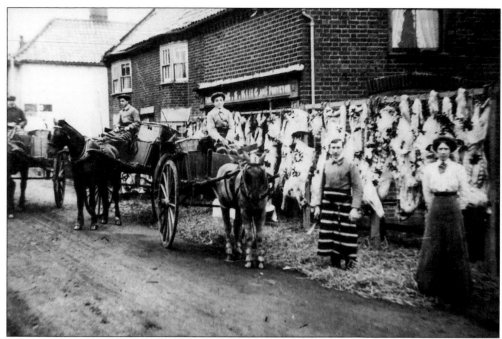

High Street, Wangford. Mr and Mrs S. King's butcher's shop, *c.* 1912. Left to right: F. Keeble, Louis Rumbelow, Arthur Fisk, Sam and Florrie King. It is Christmas time, the carcasses hanging on the rail outside the shop are decorated, chiefly with holly, as was the custom. The three men in the butcher's traps are about to set off on their delivery rounds.

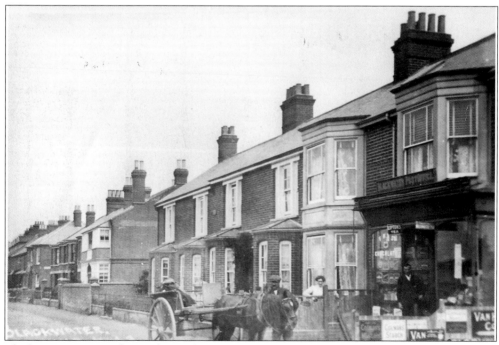

Blackwater, Lowestoft Road, Reydon.

Boyden's Stores, Mount Pleasant, Reydon.

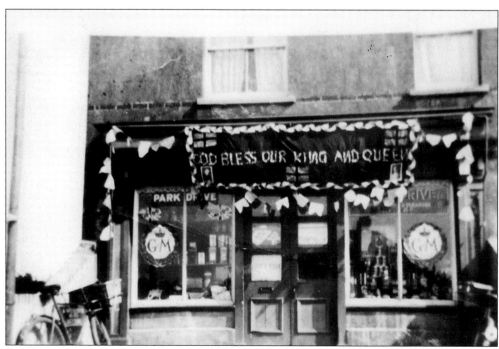

Boyden's Stores decorated for the Silver Jubilee of George V and Queen Mary, May 1935.

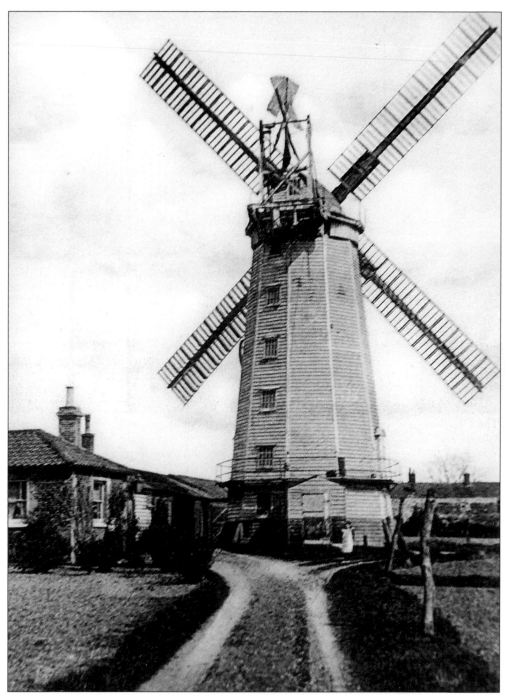

Smock Mill at Wangford, *c.* 1902. Owned by John Martin, who used wind and steam to grind corn. The mill, which was in use until it burnt down in 1928, stood on the site now occupied by the village hall and the Mill Field housing estate. Smock Mills were similar to Tower Mills with only the cap moving to allow the sails to face the prevailing wind. The fantail, which can be seen clearly in this photograph, turned the cap and thus the sails towards the wind.

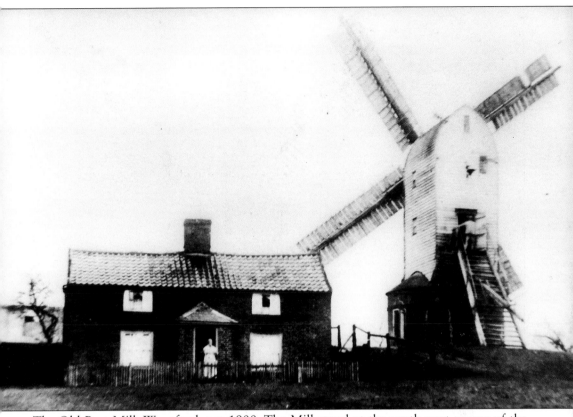

The Old Post Mill, Wangford, pre-1900. The Mill stood at the north-west corner of the village, but nobody living in Wangford or district today can remember it still standing. With Post Mills the whole body (or Buck) of the mill had to be turned for the sails to face the wind. Some had to be turned manually, others were turned automatically by a fan-carriage. The timber in the construction was the central post which was held in position by four sloping bars. As with this mill, roundhouses were added to protect the timber trestles. Here the miller can be seen about to enter the mill. At the front of the house his wife poses for the photographer.

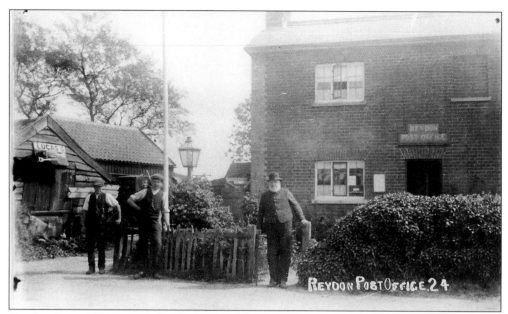

Reydon Post Office. Note the flag pole and the lamp post. On the left is the blacksmith's shop which was in conjunction with the Post Office.

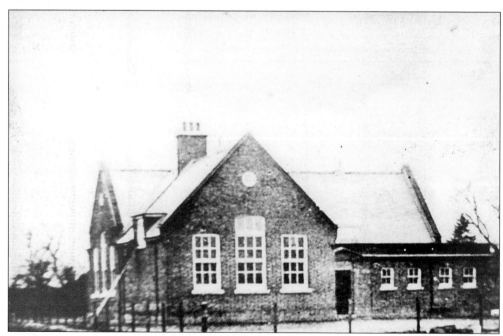

Reydon Council School, 1908. The school had just been built.

Three

Southwold

'Southwold, a bright, breezy little town.'
Olive Cook.

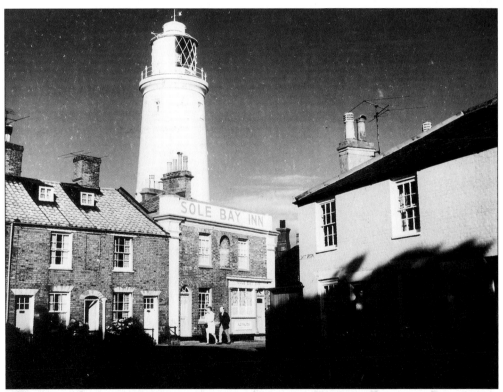

The Lighthouse and Sole Bay Inn, 1960. To take this picture the photographer stood on East Green in the shadow of the splendid Wych Elm Tree, which was destroyed by Dutch Elm Disease in the 1980s. The lighthouse was built in the 1890s, well away from the sea and the danger of erosion. The Inn sells Adnams beer which is brewed only a few yards away.

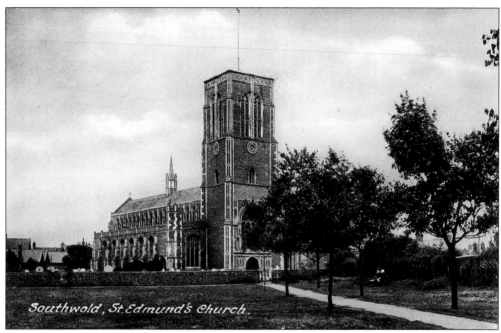

Bombs during the Second World War destroyed the Victorian stained glass whose absence now gives the church a bright and cheerful interior.

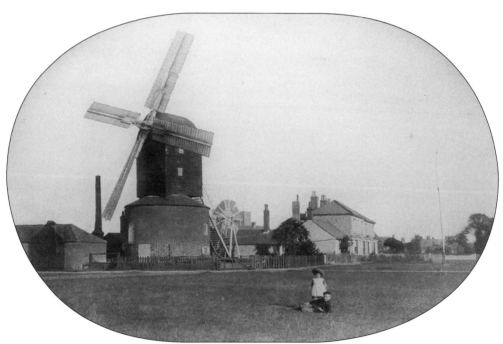

The Old Black Mill, a Post Mill which stood on Southwold Common. The mill also had a steam engine at the back — note the chimney. It was brought to Southwold from Yarmouth in 1789, but was damaged by fire in 1863.

A CAUTION,

AND

REWARD.

WHEREAS several persons in Southwold, are in the habit of keeping asses and turning them out at night, by which the property of many of the Inhabitants have been much injured, and some young trees in a small plantation belonging to Mr. Robinson, entirely destroyed.---Such persons are hereby informed, that the most effective legal measures will be adopted ; and further, that a man-trap and two spring guns will, in future, be placed in the grounds alluded to.---Parents, therefore, in particular, are earnestly requested to caution their children and others against the danger of a trespass which must be *wilful*, as it cannot be committed *without difficulty.*---And whereas, it is understood, that gangs of boys, or young men, have for some time past, made a practice of prowling about in the Evening for the sole purpose of doing mischief, by whom many families have been much annoyed, some of which depredators did, about Nine o'Clock in the Evening of the 13th Instant, (in the hearing of the family, who supposed the noise to proceed from a neighbouring house) destroy, with bludgeons, or some such instruments, one of the large stone balls at Mr. Robinson's door.---If any one of the party concerned in this transaction, will give information so that *his accomplices* may be brought to justice, he will be *liberally rewarded.*

Southwold, the 23rd, *March,* 1820.

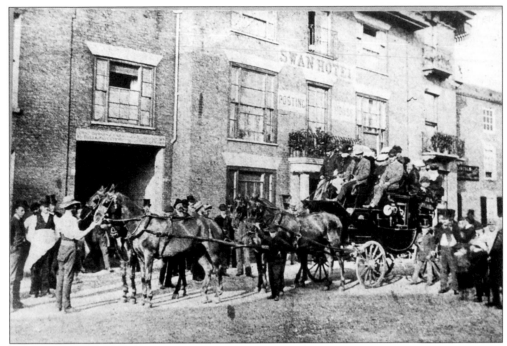

A stage coach outside The Swan, Market Place, late nineteenth century. The Swan used to be known as the Old Swan and Royal Hotel and Posting House, 'for families and gentlemen, good coffee rooms, billiard and bath rooms, liberal table, carriages for hire, 'bus meets all trains.'

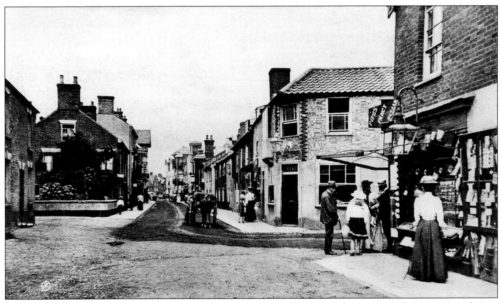

East Street, c. 1907. First on the right is Francis Pipe's shop, a jewellery and a fancy repository, which has been described as an Aladdin's Cave supplying all manner of goods. The premises later became a gentlemen's outfitter's shop, and is now a bookshop known as Pleasures.

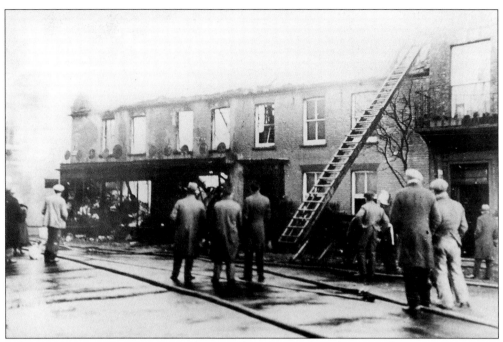

A fire at W. Denny's Groceries and General Store, Market Place, April 1931.

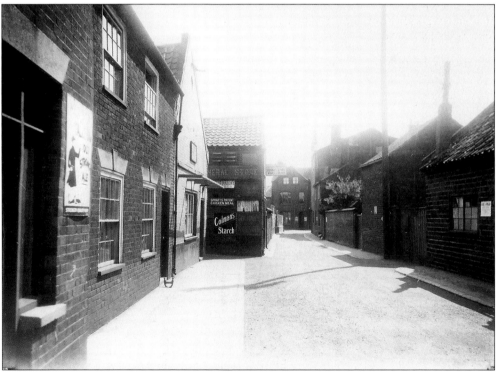

Church Street in the 1930s. On the left: The Bricklayer's Arms, a fish and chip shop, and
W. Denny's warehouses from where he traded while his shop, destroyed by fire, was being
rebuilt.

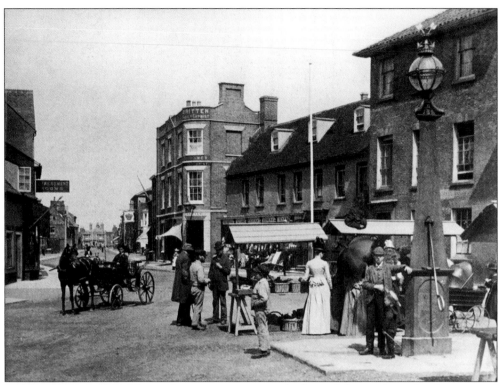

Market Place, *c.* 1880. The stalls are set up on certain days of the week, under the terms of an ancient Charter. The pump in the centre was made at Child's Foundry, just off Market Place. All the ornate gas lamp-posts in Southwold were cast there, and the foundry also did a lot of work at the gasworks and for the Southwold Railway when it was being constructed.

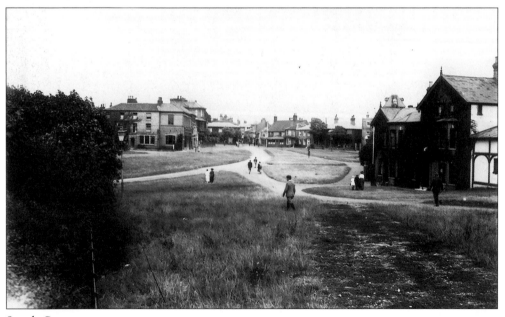

South Green.

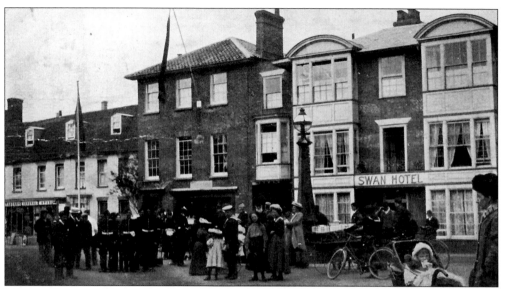

Market Place and Swan Hotel, *c.* 1909.

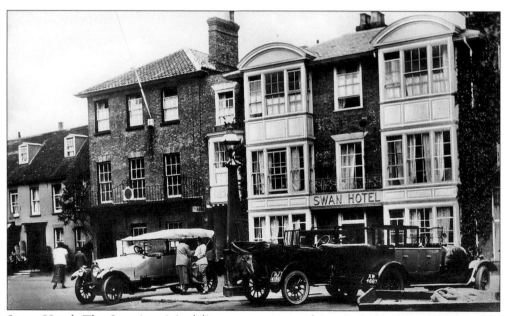

Swan Hotel. The Swan's original licence was granted in 1763. 'We got to Southwold about 12 o'clock and there we supped, dined and slept at an indifferent Inn, but very civil Landlord, the Old Swan, kept by one Berry . . . Before Dinner we walked on the Beach which is close to the Town, for near three Hours, and after Dinner two Hours more, looking after curious Pebbles etc . . .' (The Revd. James Woodforde. Spring 1786).

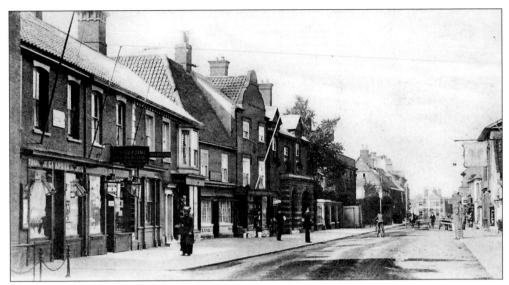

High Street, *c.* 1904.

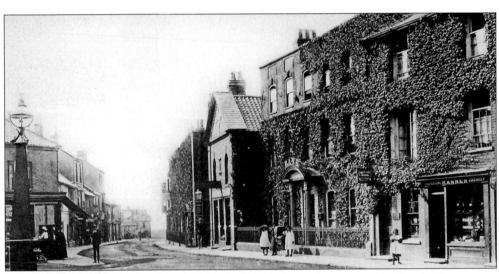

Queen Street and The Bank, *c.* 1908. In the eighteenth century the Bank House was the home of John Robinson, who dominated Southwold town politics for almost forty years.

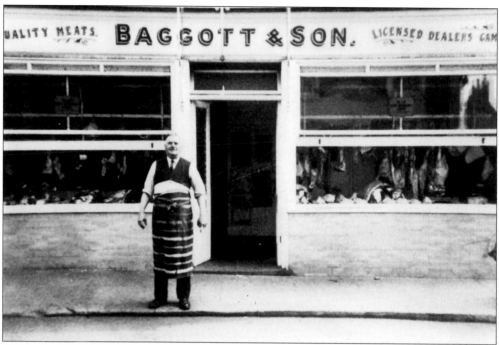

Baggott & Son, Trinity Street, butchers and dealers in game. Standing outside the shop is Frederick Baggott.

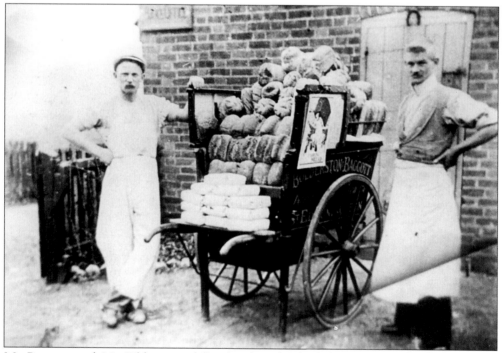

Mr Baggott and Mr Bilderston, delivering bread. The bakery was in Field Stile Road/ St Edmund's Road.

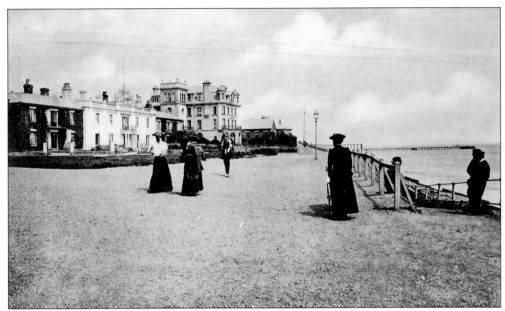

Centre Cliff. The tall building is the Centre Cliff Hotel which opened in 1887. After the Second World War, it was converted into flats.

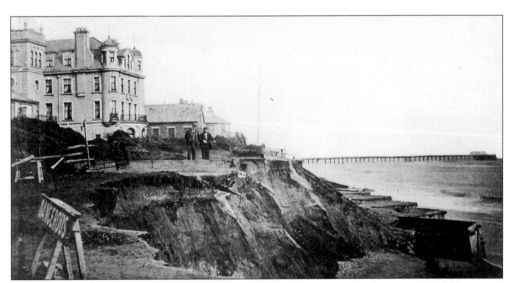

Damage at Centre Cliff. In 1900, Southwold Corporation spent large sums of money to improve the seafront and protect the town from the sea and in 1907, owing to damage caused by storms, a further £3,000 had to be expended.

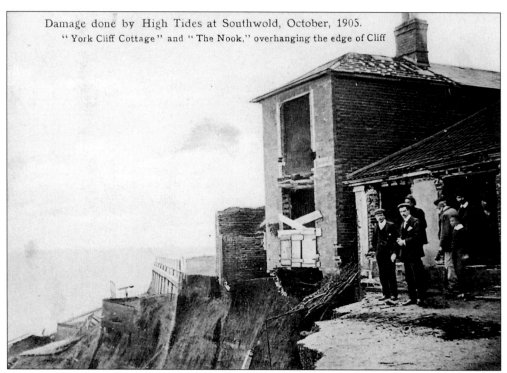

Damage done by high tides, October 1905. Both York Cliff Cottage and the Nook are in very precarious positions.

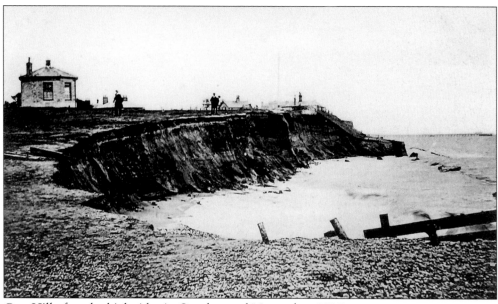

Gun Hill after the high tides in October and November 1905.

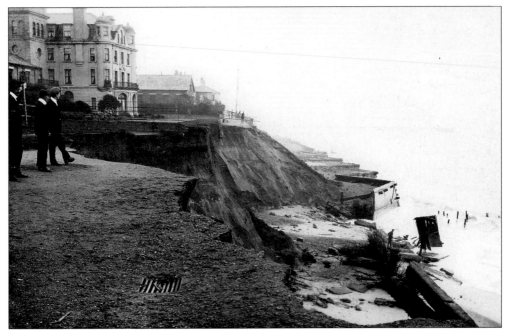

Centre Cliff, 2 October 1905. 'Oh, so slowly does the sea beleager us.' (Alfred Lord
Tennyson).

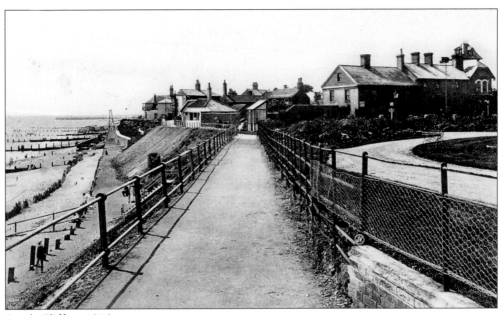

South Cliff, *c.* 1910.

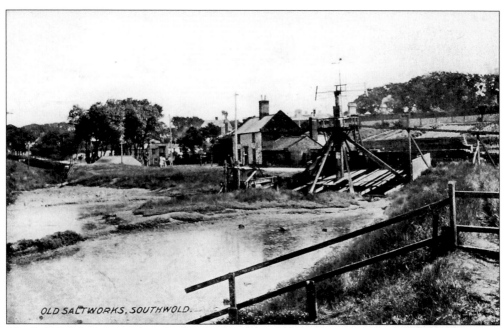

The Salt Works, situated at the head of Salt Works Creek. In the Domesday Survey there were twenty salt pans listed for the county, either along the coast or within reach of the flow of salt tides. In his will, William Godell of Southwold mentioned his houses 'with all the salt within them.' The early salt business in Southwold incorporated the Town Arms stating the date 1660 as the year of establishment. In 1765 a lease of ninety-nine years on the saltworks was granted to Joseph Barker of Manchester, and in 1848 Wilkinson and Littleboy of Norwich had the works. It was sold early this century to the Southwold & London Trading Company, afterwards coal and sea-water baths were added. It is believed that the Southwold salt works were the last to operate in Suffolk.

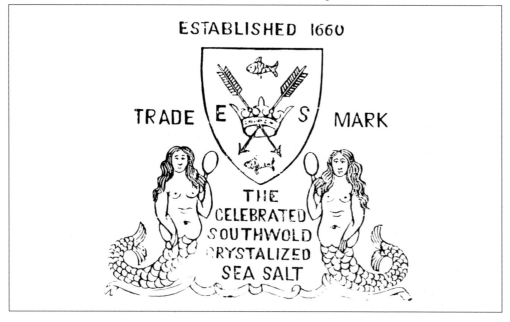

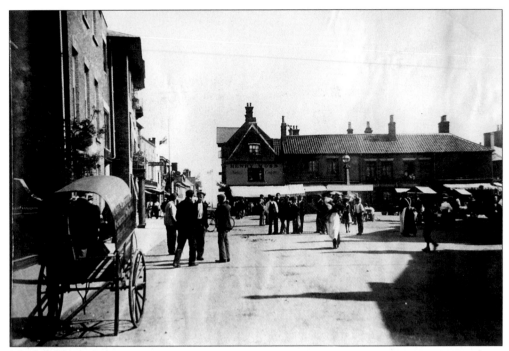

Market Place.

Ferry Road.

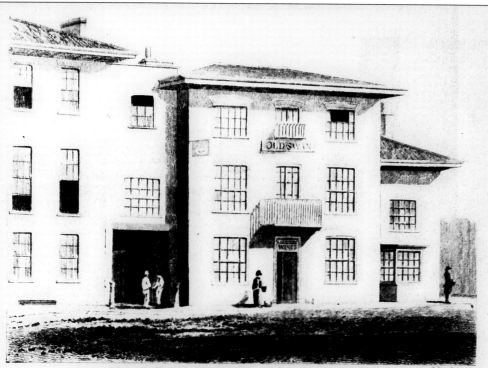

OLD SWAN INN, SOUTHWOLD.

T. BOKENHAM

RETURNS his most grateful acknowledgments to the NOBILITY, GENTRY, and COMMERCIAL GENTLEMEN frequenting the TOWN of SOUTHWOLD, and the Public in general, for the liberal encouragement he has received; and begs respectfully to inform them, that he has recently made such additions and improvements to the above old-established Inn, as enables him to accommodate Visitors for any period, with comfortable Beds, and Sitting-Rooms commanding extensive and pleasant views of the sea, and the adjacent country.

T. B. hopes, by an unremitting attention, and the select quality of his Wines and Liquors, all which he imports, to merit their future patronage.

An excellent Billiard Table and Bowling Green, commodious Stables and Coach Houses, neat Post Chaises and careful Drivers.

Lodgings engaged by applying at the above Inn, which is situated nearest the sea.

SLOMAN, Engraver and Printer, Yarmouth.

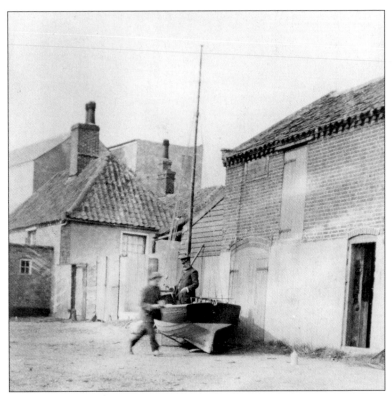

Blackshore. The Harbour Inn on the far left. In the eighteenth century it was called the Nag's Head.

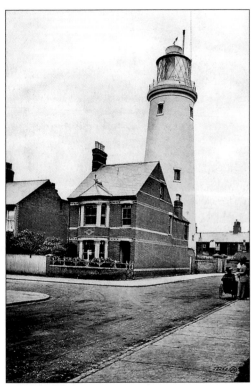

The Lighthouse. Note the bath chair on the right.

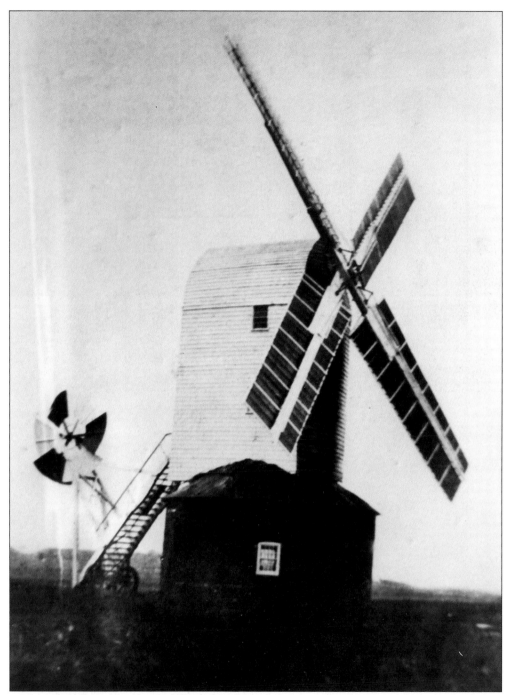

Baggott's Mill, Field Stile Road. Southwold had three windmills. The oldest was the White Mill, a post mill which stood south of the Common. In July 1789 the Black Mill was erected on the Common. The post mill shown here was erected in 1841. It was unoccupied in the early 1850s and then in 1855 Amos Barber of Walberswick hired it. By 1876 it was in the possession of Mr Baggott and was destroyed by fire on 2 February 1876. In the same year the Baggott family built two brick houses on the site.

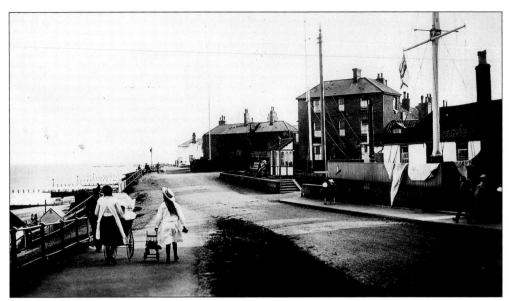

North Parade, *c.* 1910. The Coastguard Station is on the extreme right. The coastguards later moved to the Roundhouse on Gun Hill. In the early 1800s the Collector of Customs in Southwold repeatedly asked for dragoons and cutters to be stationed at Southwold to help combat the large gangs of smugglers.

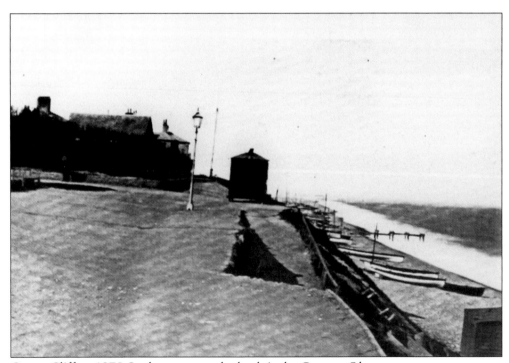

Centre Cliff, *c.* 1875. In the centre at the back is the Camera Obscura.

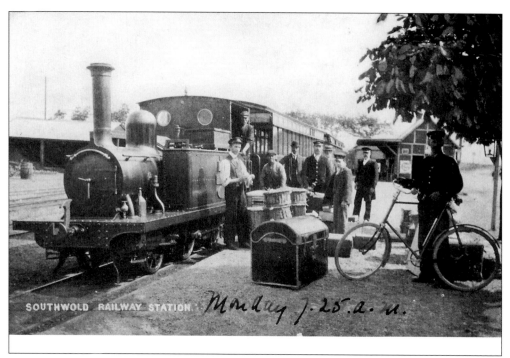

SOUTHWOLD RAILWAY STATION *Monday 7.25.a.u.*

The Harbour, River Blyth. The ferry carried passengers between Southwold and Walberswick. The ferryman was George Todd. The ferry was reputed to be haunted. One visitor asked George Todd to row him across the river, and walking to the shore he overtook an old man leading a child by the hand. He asked the ferryman to wait for them but then saw they had vanished. 'We never waits for them', said the ferryman. Many people have had the same strange experience.

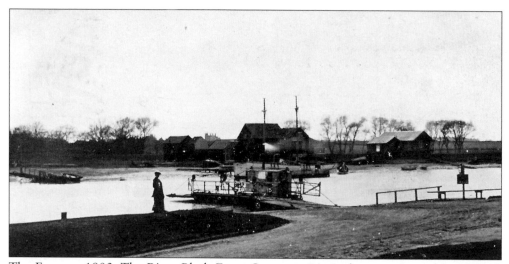

The Ferry, *c.* 1903. The River Blyth Ferry Company Limited was registered in 1885. A steam pontoon was run on chains from bank to bank. This ferry service continued until the Second World War.

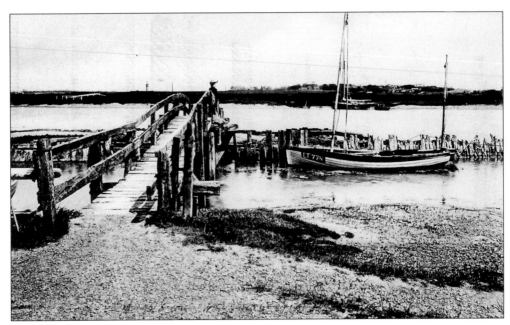

River Blyth.

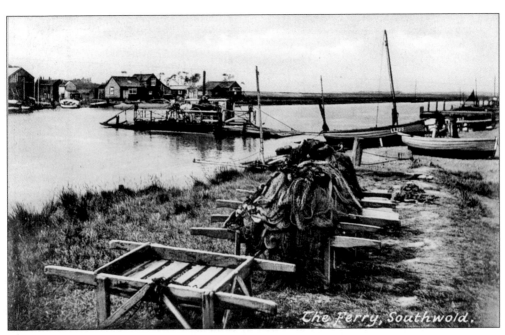

The Ferry.

Hollyhock Square. These fishermen's cottages were destroyed by enemy action on 15 May 1943. In total, 119 high explosives and 2,689 incendiary bombs were dropped on Southwold during the Second World War.

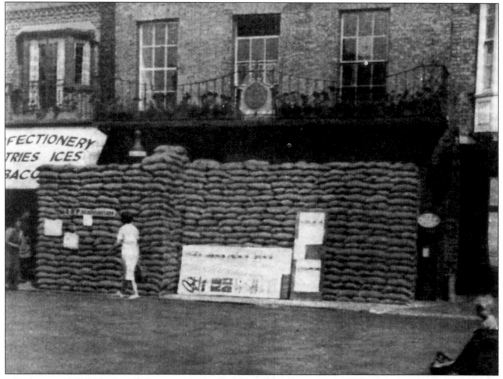

The Town Hall protected against air raids by sandbags, 1939. Seventy-seven properties were destroyed and 2,229 damaged by enemy action during the Second World War.

Park Lane. Agnes Strickland, author of *Lives of the Queens of England*, lived at 25 Park Lane.

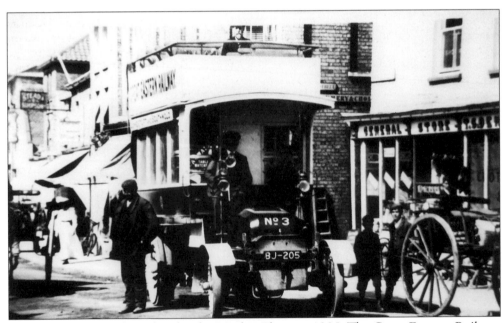

A Great Eastern Railway bus by the Market Place, *c.* 1905. The Great Eastern Railway started a bus service between Southwold and Lowestoft in 1904.

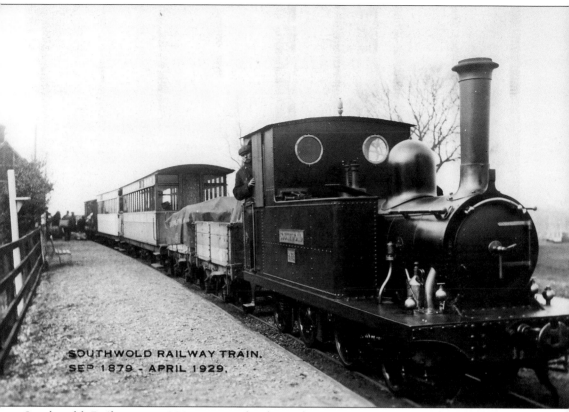

SOUTHWOLD RAILWAY TRAIN.
SEP 1879 - APRIL 1929.

Southwold Railway *c.* 1900. Previously the railway passengers came from Barsham Station to Southwold by horse-drawn omnibus, a distance of nine miles. A private company was formed with a capital of £67,990 and a Southwold Railway Bill was presented to Parliament in 1876. Work began on the line on 3 May 1878 and it opened on 24 September 1879. The line consisted of a single track of 3ft gauge with a swing bridge over the River Blyth. The Board of Trade restricted the speed of the train to sixteen miles per hour, and if an engine driver exceeded that speed he made himself liable to two years' imprisonment. Initially the line had three locomotives, six carriages, and six trucks. Later another locomotive was added and when the line closed in 1929 it had thirty trucks. The line had brought passengers to and from Southwold, luggage and coal to Southwold, taken fish from the harbour and from the intermediate stations collected churns of milk en route to London. On its opening the *Halesworth Times* reported, 'The motion of the carriages is remarkably easy. The carriages themselves are airy and spacious, and very superior in construction.'

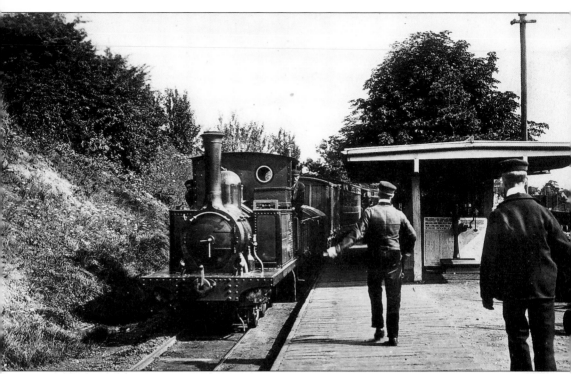

Halesworth Station on the Southwold Railway. The line ran between the termini of Halesworth and Southwold, a distance of nine miles. When it opened there was only one intermediate station, Wenhaston. Other stations were later opened at Walberwick and Blythburgh.

9th July, 1923, and until further notice.

UP TRAINS. WEEK DAYS. SUNDAYS

	a.m.	a.m.	noon	p.m.	p.m.	p.m.	p.m.
SOUTHWOLD dep.	7.30	9.45	12.0	2.20	5.23	7.26	5.19
WALBERSWICK ,,	7.35	9.50	12.5	2.25	5.28	7.31	5.24
BLYTHBURGH ,,	7.49	10.4	12.19	2.39	5.42	7.45	5.38
WENHASTON ,,	8.0	10.15	12.30	2.50	5.53	7.56	5.49
HALESWORTH arr.	8.11	10.26	12.41	3.1	6.4	8.7	6.0

DOWN TRAINS. WEEK DAYS. SUNDAYS

	a.m.	a.m.	p.m.	p.m.	p.m.	p.m.	p.m.
HALESWORTH dep.	8.40	10.45	1.0	3.45	6.37	8.12	8.0
WENHASTON ,,	8.51	10.56	1.11	3.56	6.48	8.23	8.11
BLYTHBURGH ,,	9.2	11.7	1.22	4.7	6.59	8.34	8.22
WALBERSWICK ,,	9.15	11.20	1.35	4.20	7.12	8.47	8.35
SOUTHWOLD arr.	9.21	11.26	1.41	4.26	7.18	8.53	8.41

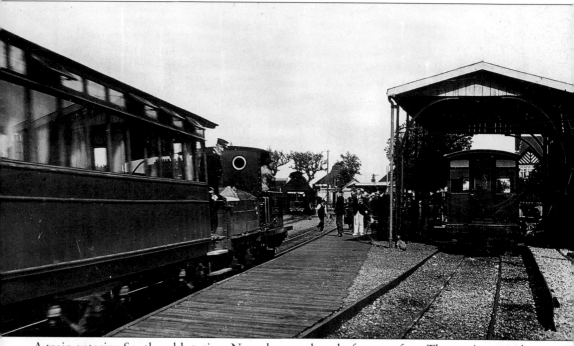

A train entering Southwold station. Note the wooden platform surface. The carriages each had six wheels and open-ended balconies — there is a carriage in the shed on the right. In 1914 a branch line to the harbour was constructed but the war ruined the prospects of Southwold's fishing industry. During the First World War and up to 1921 the War Department had control of the railway line.

Cheap Return Tickets

TO

LONDON (LIVERPOOL STREET.)

FROM	FARES for the Double Journey.	
	FIRST CLASS.	THIRD CLASS.
SOUTHWOLD	27/2	12/4
WALBERSWICK	26/11	12/2
BLYTHBURGH	26/3	11/10
WENHASTON .	25/10	11/7

The above Tickets will be available for return by any Train only on the Sunday (if Train Service permits) or Monday following the date of issue.

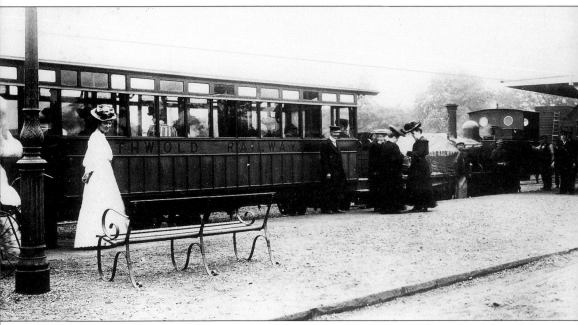

A train in Southwold Station, *c.* 1909. The wooden seats were along the sides of the coaches. But the elaborate hats of the women are almost as noteworthy as the elegant train. The platform surface is gravel in this picture.

CHEAP EXCURSION TICKETS

Will be issued to

SOUTHWOLD

Every Monday and Thursday

Stations.		Times.		Fares for Double Journey.	
		a.m.	p.m.	1 Class.	3 Class.
Halesworth	dep.	8 40	1 15	2/-	1/-
Wenhaston	,,	8 49	1 24	1/6	9 d.
Blythburgh	,,	9 0	1 35	1/-	6d.
Southwold	arr.	9 17	1 52	—	—

The Tickets will be available for Return on day of issue only from Southwold by the 5.25 p.m. during May and the 5.25 and 7.13 p.m. Trains during June.

Over 700 passenger tickets were sold on August Bank Holiday 1899. Almost 11,000 passengers used the line in 1913 in addition to the freight trade.

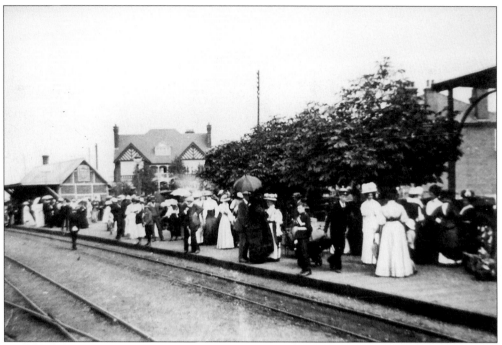

Waiting for the train, Southwold Station. The tall building in the background is the Station Hotel, built in 1900.

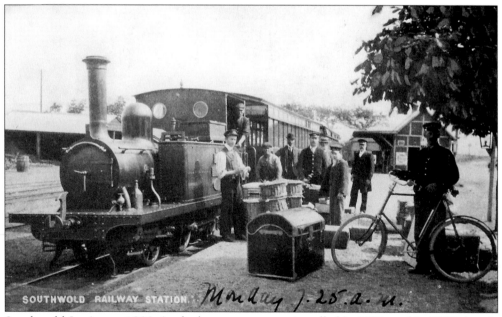

SOUTHWOLD RAILWAY STATION. *Monday 7.25.a.u.*

Southwold Station, *c.* 1903. A telephone system was installed in 1902, and in 1905 electric lighting replaced the oil lamps on the platform. Note the portmanteaux on the left and the cart on the right. The Swan Hotel sent a carriage to meet every train.

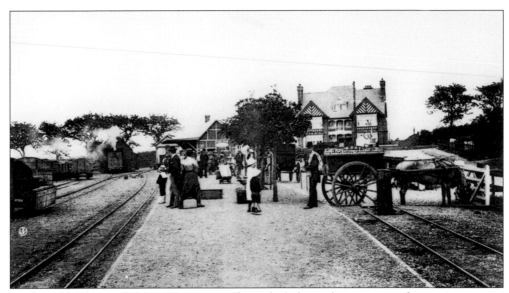

Southwold Railway Station. The cart on the right belonged to Mr Day, the carriage agent. The carriage by the tree in the centre of the photograph probably belonged to the Swan Hotel.

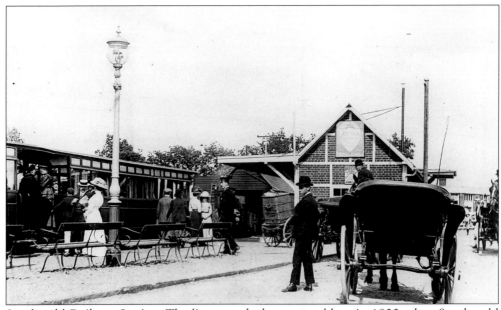

Southwold Railway Station. The line was dealt a severe blow in 1922 when Southwold Corporation allowed motor coaches to operate. In 1929, after fifty years of useful service, the line closed. On 11 April 1929 the last train left Southwold at 5.25 p.m, on its return, 'a wreath was placed on the smokebar of the engine. People did not know whether to laugh or cry . . . the employees, numbering thirty, received notice of its closing down only two weeks ago.'

Four

Fishing

'A fine night to land our nets,
And safe in with the haul,
Pray God hear my prayer.'
 Fisherman's prayer.

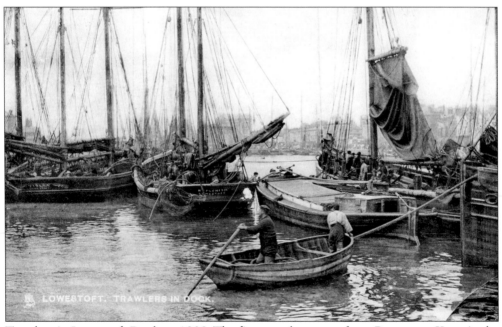

Trawlers in Lowestoft Dock, *c.* 1908. The first trawlers came from Ramsgate, Kent, in the 1860s.

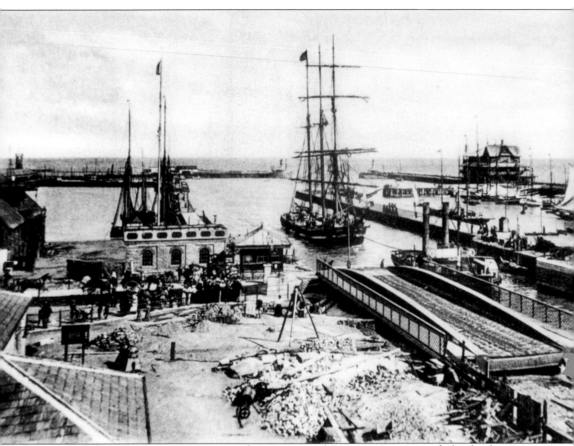

Inner Harbour Entrance, Lowestoft, *c*. 1900. The reconstruction of the harbour was completed in 1850. The tug towing a schooner past the swing bridge is the *Imperial*. In 1853, 16,000 cattle and 10,000 sheep were imported into Lowestoft.

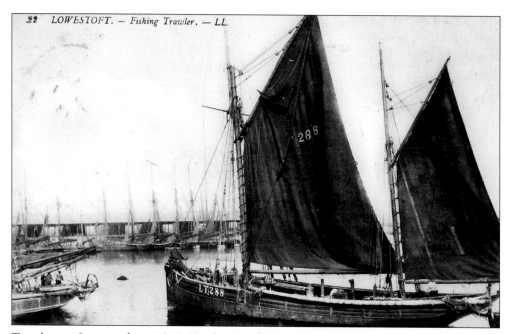

Trawlers at Lowestoft, *c.* 1910. Teodor Josef Konrad Korzeniowaki (later better known as Joseph Conrad) first set foot on English soil at Lowestoft, when he jumped ship in 1878. For some time he worked as a deckhand on a Lowestoft trawler and it was the harbour master who taught him the rudiments of the English language.

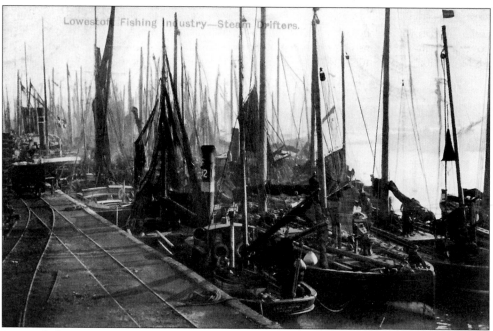

Steam drifters at Lowestoft, *c.* 1900. Lowestoft's first steam herring drifter, *Consolation*, was built in 1897.

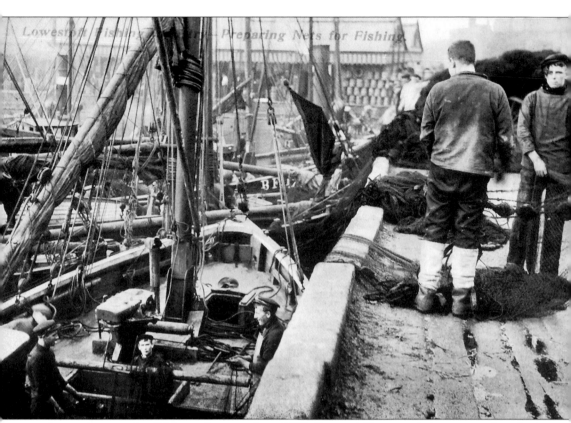

Preparing nets for fishing at Lowestoft, *c.* 1900. Steam drifters carried up to one hundred nets each. Each net was thirty-three yards long by fourteen yards deep, lashed together and then thrown overboard.

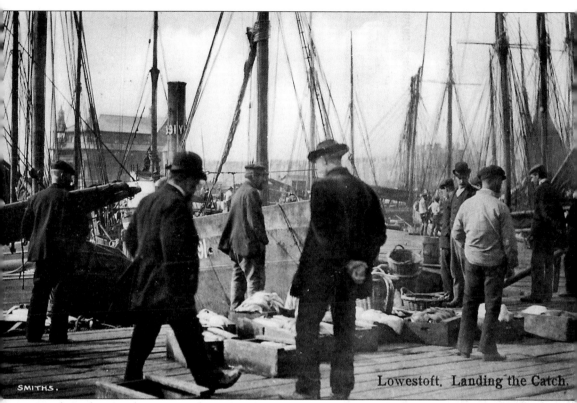

Landing the Catch, Lowestoft, *c.* 1900. The railway gave a great boost to Lowestoft's fishing when it opened in the town in 1847. The years from 1900 to 1913 were the boom years for the industry. The largest catch ever landed in Lowestoft was achieved in 1913.

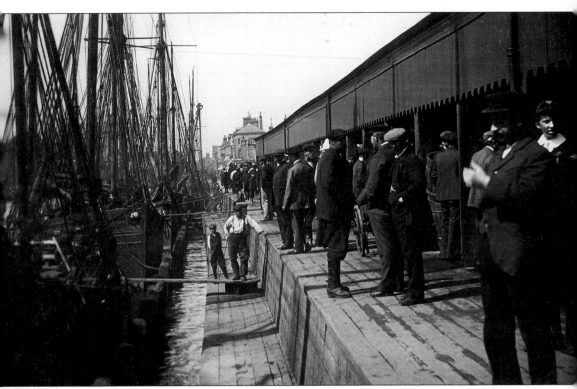

The Fish Market. The first proper fish market in Lowestoft was opened in 1872 and ten years later it was extended. Lowestoft fish could be sent quickly to all parts of the country by rail. Extensive use of ice to preserve the fish dated back to the 1840s.

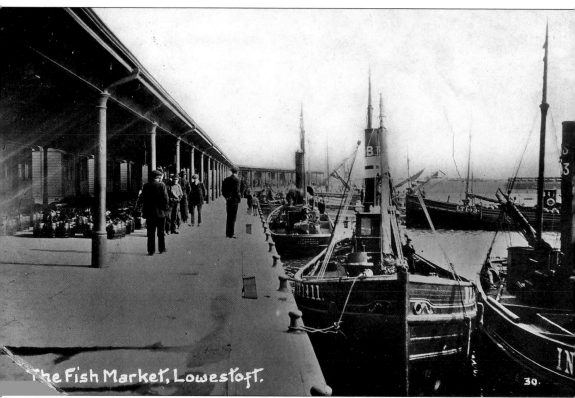

The Fish Market, Lowestoft, *c.* 1911.

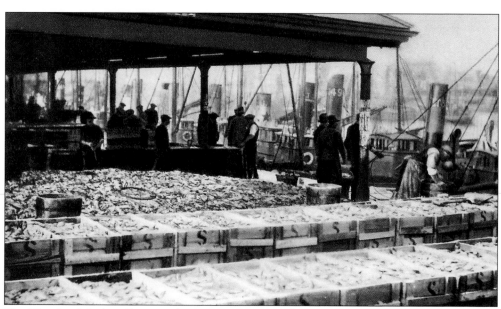

The Herring Market, Lowestoft, *c.* 1911. Herring for export was called 'Klondyking'. It ceased with the commencement of the First World War. The 'Klondykers' were those who sent large amounts of iced herring to Germany when a huge catch was landed.

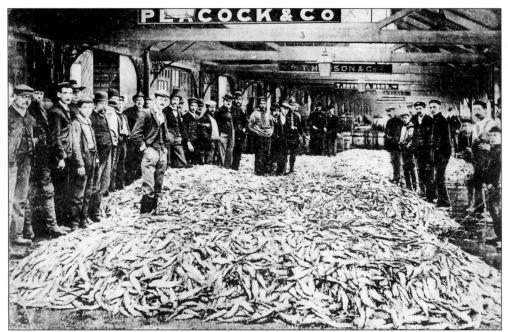

Herrings at Lowestoft, *c*. 1900. Herrings were bought by the Scots curers; large quantities were packed in ice and sent to Germany, others went by rail to various part of Britain. But a lot went to Lowestoft smokehouses and were turned into bloaters, kippers and red herrings.

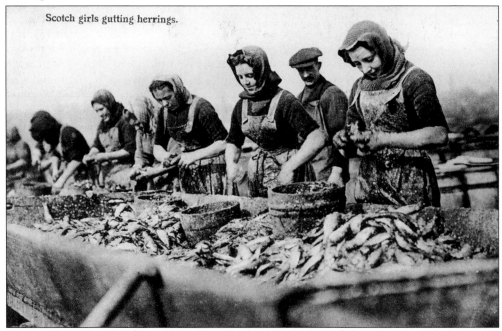

Scotch girls gutting herrings.

Scots girls at Lowestoft, *c*. 1900. During the 1860s Scots fishermen started coming to Lowestoft. They came in sailing craft, but by 1913 most of their six hundred boats were steamers. The large number of Scottish vessels led to the construction of a new dock in 1902.

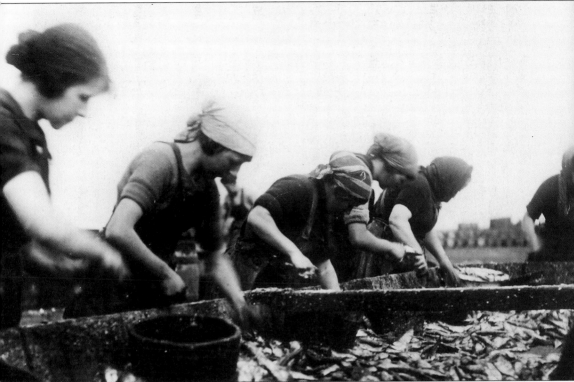

Scots girls gutting herrings at Lowestoft, *c.* 1900. Hundreds of Scots girls came to Lowestoft for the herring season. Special trains were run to bring them. On arrival they would settle in at lodgings in the town which had been found for them by the fish curers' agents. The girls' job was to gut and pack the herrings. It was cold, arduous, and monotonous work. They wore oilskins, which they called 'balm-skins', and bandaged their fingers for protection — they had rags on all fingers before they started work. There was no limit to the day; they had to work until the herrings were finished. As long as the fish kept coming in they kept working. When landings were heavy they worked all through the night by the light of flares.

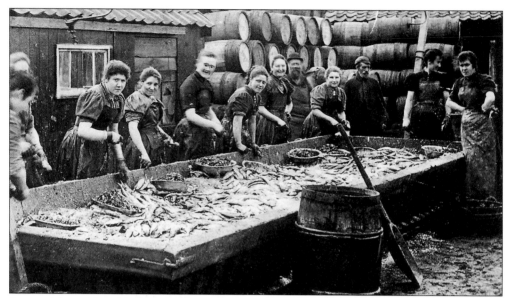

Scots girls gutting herrings at Lowestoft, *c.* 1908. 'Fancy standing back to the North Sea for ten hours or more handling cold fish.' Although here their backs at least had some shelter. When the herring season ended (about mid-December), the girls returned to Scotland with goods and Christmas presents bought in the Lowestoft shops. They were not mean, they took wonderful things home.

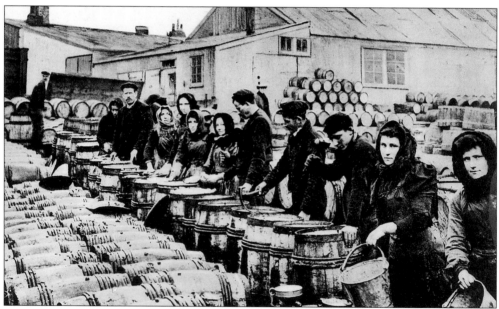

Men as well as women came from Scotland for the fish curing. The men always wore caps. After removing the gut ('gyping'), the fish were salted. For the export trade they went through the process of 'rousing' whereby the fished were mixed with salt by means of a wooden shovel — this was known as roaring. For local trade herrings were soaked in brine and then smoked.

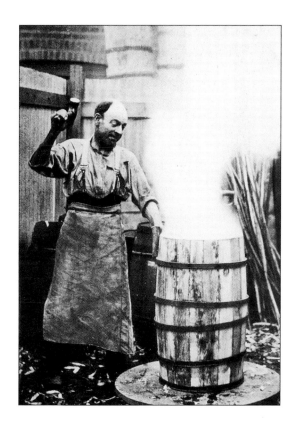

Herring barrel making, *c.* 1900. Some of the fish curers made barrels and had their own coopers' sheds.

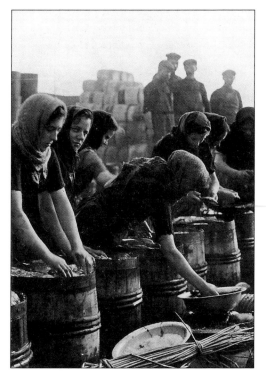

Packing herrings at Lowestoft, *c.* 1904. After gutting, the herrings were packed in barrels between layers of salt.

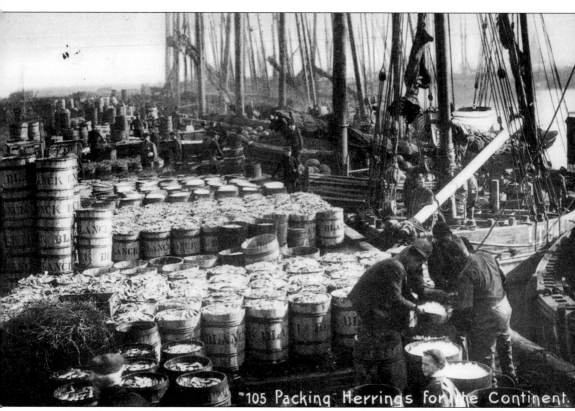

105 Packing Herrings for the Continent.

Packing herrings for the Continent, 1906. In 1907 the total value of imports into Lowestoft was £89,819. The total value of exports was £352,231 of which £350,086 worth was herrings.

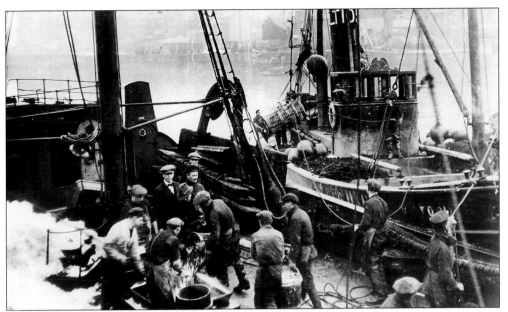

Loading a German trawler with herrings at Lowestoft, *c.* 1910.

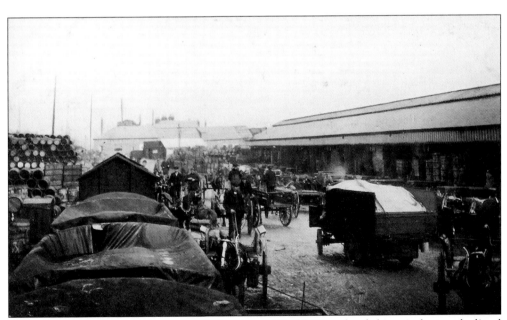

Lowestoft Fish Market. Because of the First World War the fishing industry declined — never again to reach its former prosperity. During the war most of Lowestoft's drifters were requisitioned for minesweeping. However, its sailing smacks went on fishing in the North Sea, but suffered huge losses by the German U-Boats.

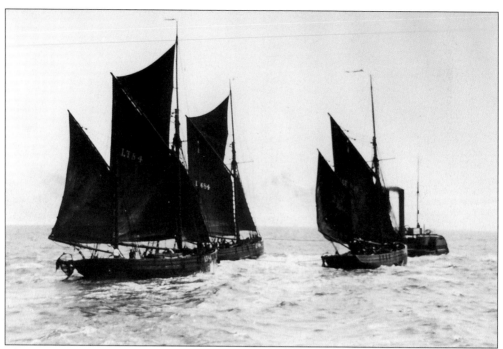

The tug *Imperial*, tugging three smacks. LT84 was the *Eclipse*, built in 1906 and owned by Mr A. Evans. LT684, *Boy Claude*, was built in 1889 and owned by Mr J. Runacus. Note: LT the first and last letters of Lowestoft — where the smacks were registered.

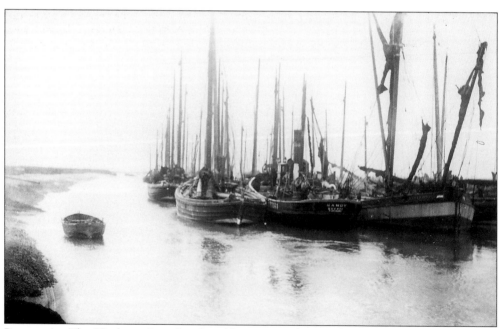

Boats near The Harbour Inn, Southwold, 1908. Left to right: a wooden-hulled fishing smack, an iron-hulled steam drifter, the *Handy Queen*, and a Thames barge.

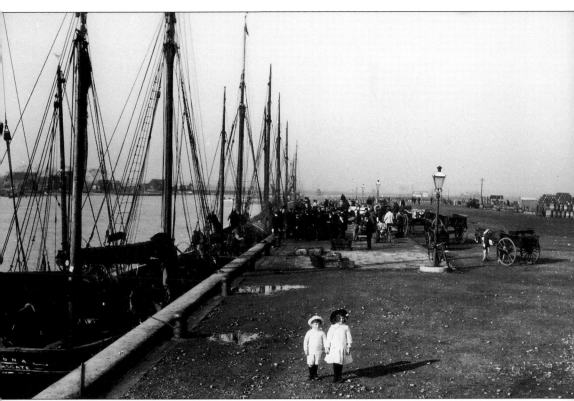

Southwold Harbour, 1910. The vessels and carts give some indication of the fishing activity. In 1745 the first Southwold Harbour Act was passed, and in the nineteenth century two piers were constructed which greatly improved the harbour. In 1905 the Harbour was sold to a company that created better facilities for entering and leaving the harbour — the concrete quay wall was built in 1906. In 1909 seventy great Scotch luggers entered the harbour on a single tide.

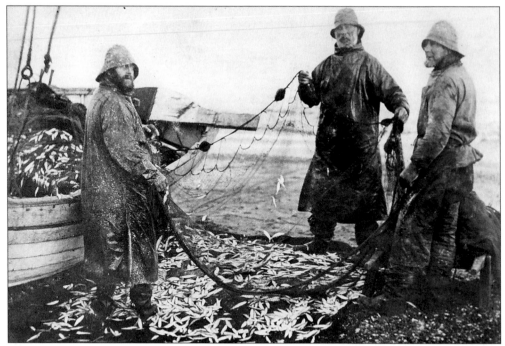

Sprat catch at Southwold, *c.* 1900. Sprats, herring, smelt, shrimps, soles and cod were caught and sent to the London market. Longshore boats landed hundreds of bushels of sprats.

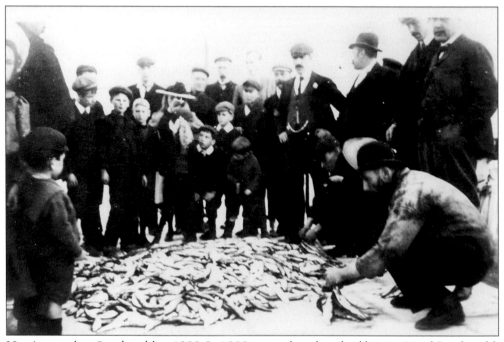

Herring catch at Southwold, *c.* 1900. In 1908, some three hundred boats visited Southwold, about 4,500 crans (28 lbs) of herring and 125,000 mackerel were landed. In 1909, 7,000 crans of herring were landed and 350,000 mackerel.

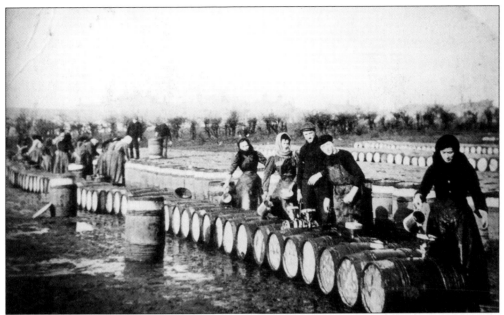

Pickling herring at Southwold, 1908. Scots girls also came to Southwold. Many of them lodged at Walberswick and were rowed across the Blyth to their place of work each day.

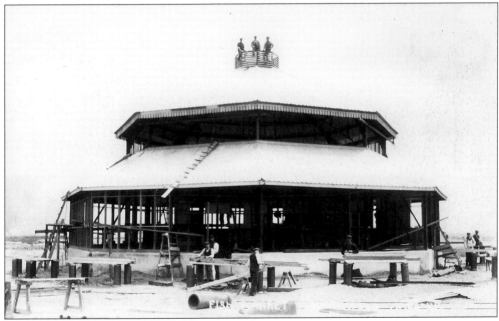

Fish Market, Southwold. Built on the Wharf at a cost of £75,000. The Treasury granted £15,000 towards the expense and a grant of £2,700 was obtained. A Light Railway Order was passed in 1913 for a railway line, but as we have seen it came too late to assist Southwold's fishing industry, its harbour or even the railway itself.

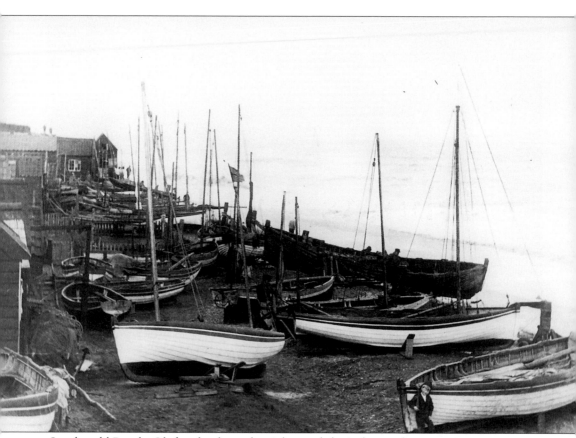

Southwold Beach. Oh for the days, the sights and the industry that are no more.

Five

Lifeboats and Losses

'For those in peril on the sea.'
William Whiting

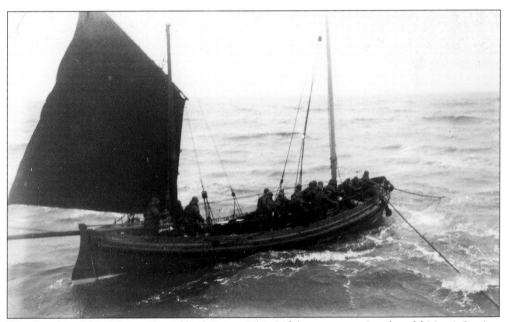

The Southwold Lifeboat, the *Alfred Corry*. This Lifeboat was at Southwold No. 1 Station from 1893 until 1918. This boat cost £800. Other boats at this Station included *Solebay*, 1841-52; *Harriett*, 1841-55; *London Coal Exchange*, 1855-93; *Bolton* (transferred from Kessingland), 1918-25; and *The Mary Scott*, 1925-4, which took part in the rescue of British forces from Dunkirk in 1940. This station closed in 1940. Lives saved 1854-1940, 152.

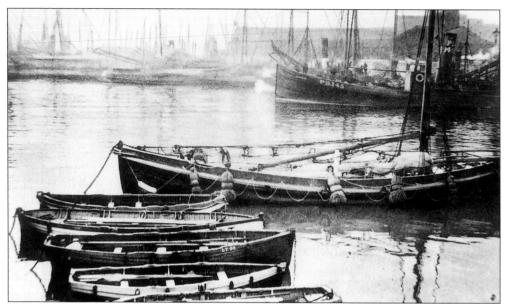

Lowestoft Lifeboat, *Kentwell*, 1919 (centre). *Kentwell* was the last of Lowestoft's rowing and sailing lifeboats. The lifeboats powered by oars included *Frances Ann* (which cost £350) between 1807 and 1849; *Loetitia*, 1849-76 (renamed in 1868); *Samuel Plimsoll*, 1876-1905; and *Kentwell* (which cost £2,197), 1905-1921. All of these vessels were housed at Lowestoft No. 1 Station. Lifeboats housed at Lowestoft No. 2 Station: *George*, 1870-86; *Mary and Hannah*, 1886-89; *Stock Exchange*, 1890-92; *Mark Lane*, 1892-1893; and *Stock Exchange* 1893-1913. No. 2 Station closed down in 1913, after sixty-eight lives had been saved. Note the steam drifters behind.

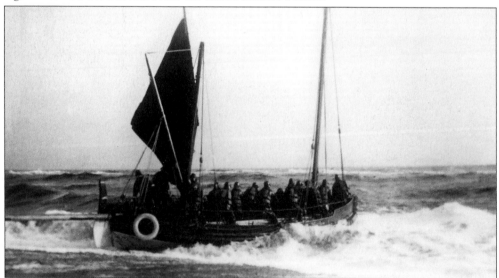

Launch of the lifeboat *Rescue* at Southwold in 1902. *Rescue* was at No. 2 Station, Southwold, 1897 to 1920. Two earlier lifeboats at the station were named *Quiver*, the first was there from 1866 to 1882, the second from 1882 to 1897. The station closed in 1920, forty lives having been saved. An Inshore Rescue Boat Station was established in 1963 and is still in operation, with a new boathouse opened in May 1994. The Inshore Boat is also named *Quiver*.

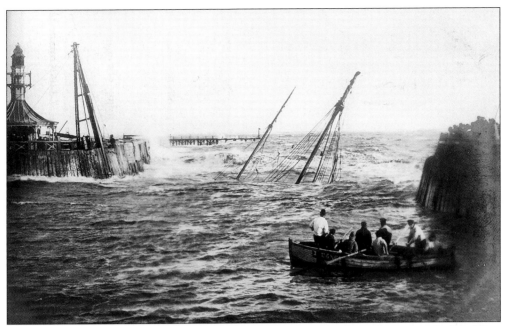

This picture was taken on 18 November 1902 when the Lowestoft smack *Sparkling Nellie* hit the pierhead at the entrance to Lowestoft Harbour and sank in the middle of the channel. She was subsequently blown up.

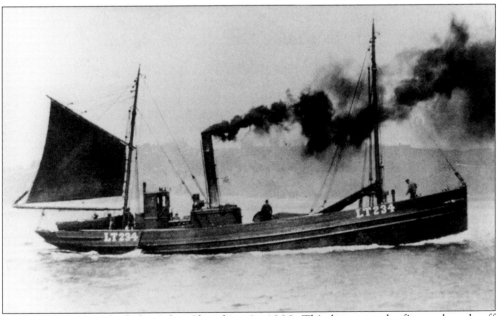

The *Golden Spur*, built by John Chambers in 1908. This boat caught fire and sank off Scarborough on 11 September 1926. John Chambers was one of Lowestoft's largest shipbuilders. 'Don't say you work for John Chambers, say you work with John Chambers' was their slogan.

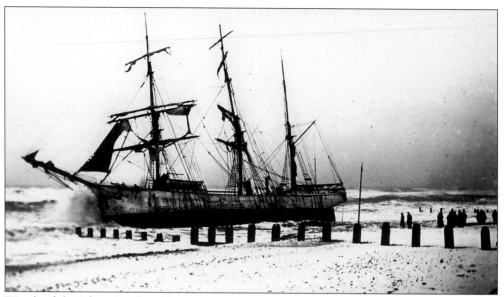

Wreck of the *Idun*, Southwold, 17 January 1912.

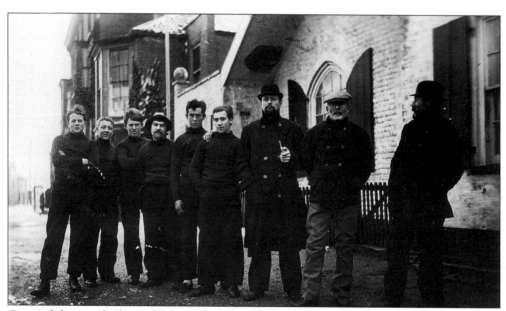

Crew of the wrecked vessel *Idun*, who were rescued at Southwold.

Six

Beside the Sea

'I do like to be beside the sea.'
John A. Glover-Kind, 1909

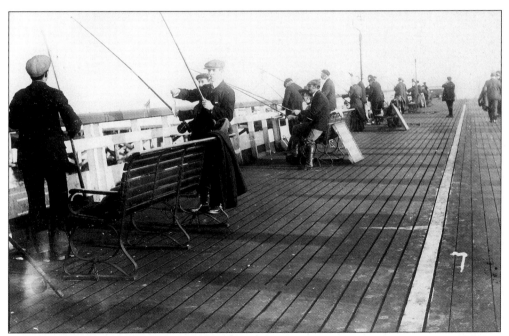

A fishing match at Lowestoft, *c.* 1908. Claremont pier was a favourite place for fishing, especially during the autumn.

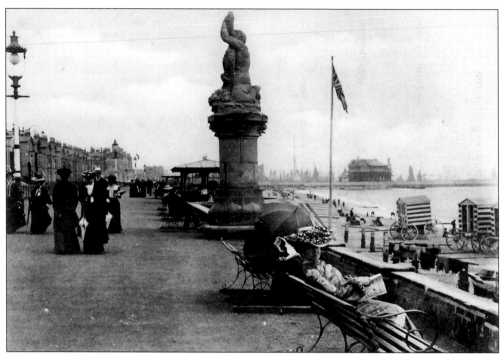

The Esplanade, Lowestoft.

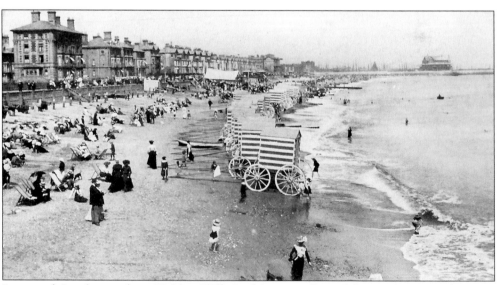

Lowestoft Beach, seen from Kirkley Cliffs. Bathing was allowed during the season between 6.30 and 8.30am and 10.30am and 12.30pm.

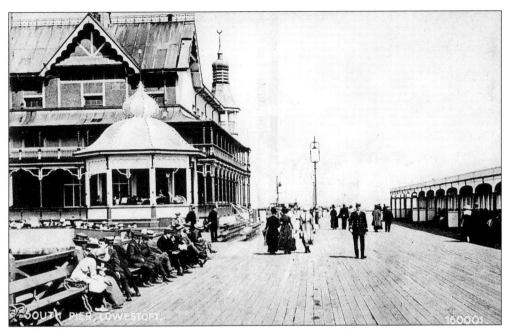

South Pier, Lowestoft.

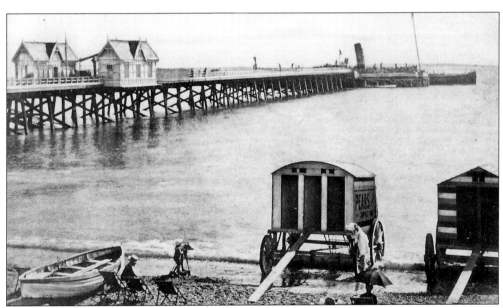

Claremont Pier, Lowestoft. Claremont Pier was built by the Coast Development Company Limited and opened in May 1903. It is 670 feet long and 32 feet wide.

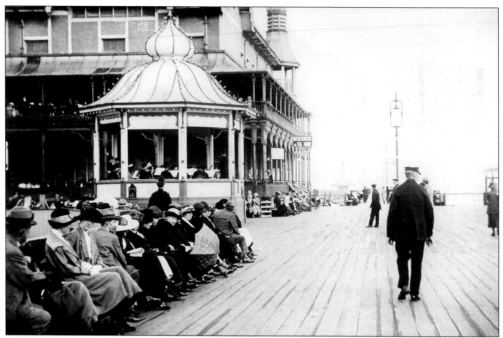

South Pier in the 1920s.

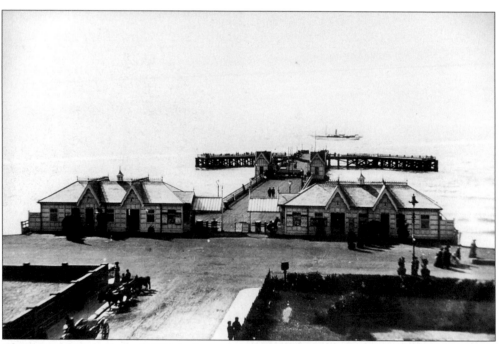

Claremont pier, built in 1905, the last pier to be built along this coast. Passengers from the Belle Steamers used to land here. Note the steam yacht in the background.

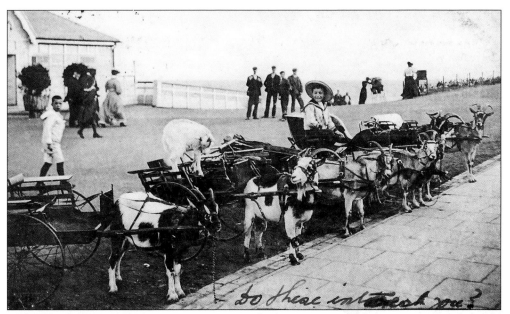

Near the Claremont Pier, *c.* 1907. Goat carts for hire, a Lowestoft feature during the early 1900s.

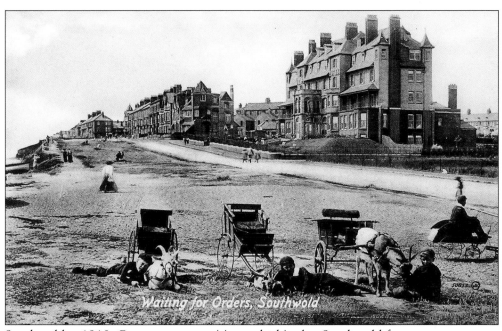

Southwold *c.* 1910. Goat carts are waiting to be hired, a Southwold feature too.

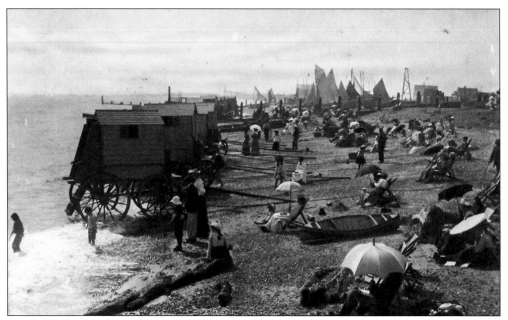

South Beach, Southwold.

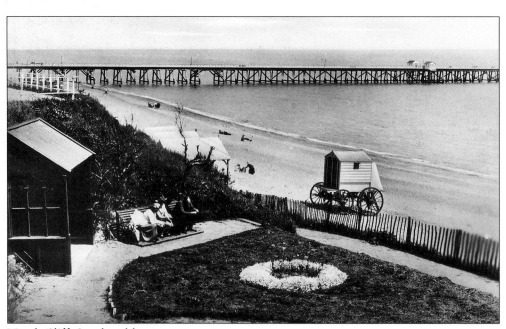

North Cliff, Southwold.

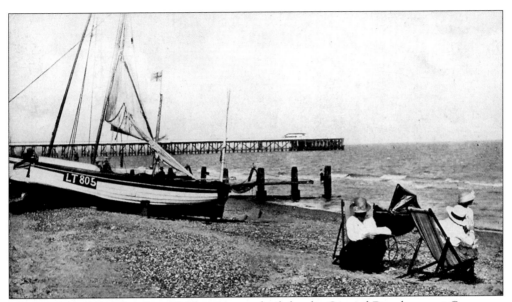

The beach and pier, Southwold. The pier was built by the Coastal Development Company in 1900. The head of the pier was washed away in 1934; it suffered further damage during the Second World War and again later.

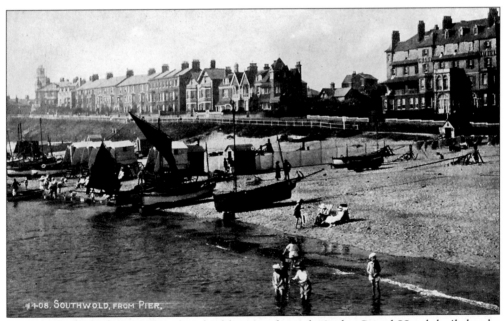

Southwold from the pier. The first building on the right is the Grand Hotel, built by the East Coast Development Company. Troops were stationed in the Grand Hotel during the Second World War. The building was later demolished having, it has been said, suffered damage from its wartime occupants.

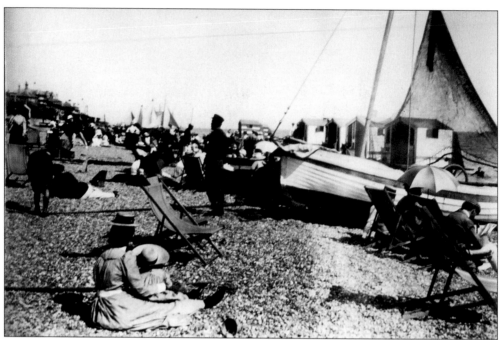

Southwold Beach.

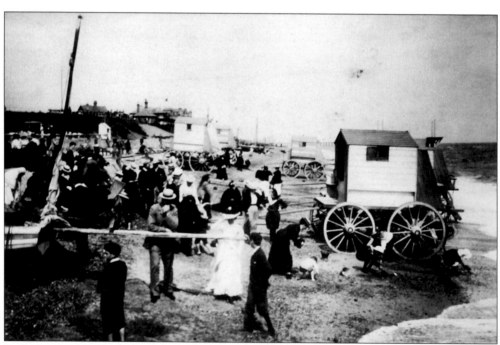

Bathing machines on Southwold beach. In 1899, the owners of the bathing machines were asked not to allow bathing after 10.00am on Sundays.

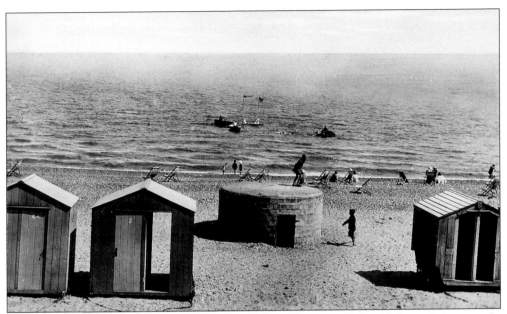

May's Bathing Machines near Gun Hill, Southwold, in 1919. Sam May was a coxwain of the Southwold Lifeboats for many years. Sam May died in 1923. He used to say of the lifeboat, 'We never fail to launch.' And they never did. The round object in the centre of the photograph is a pillbox from the war.

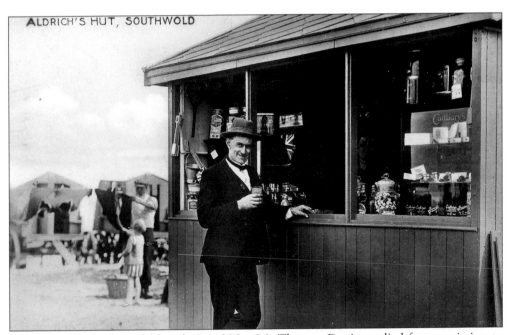

Aldrich's Hut, Southwold beach. In 1899 a Mr Thomas Davis applied for permission to place a candy stall on or near the beach, but permission was not granted.

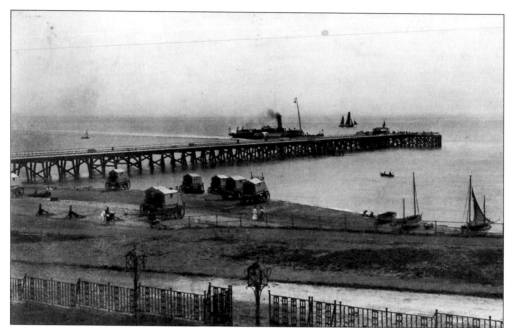

The pier at Southwold, *c.* 1906. The pier was 270 yards in length. The vessel approaching is the Belle Steamer, arriving to pick up passengers who can just be seen at the end of the pier.

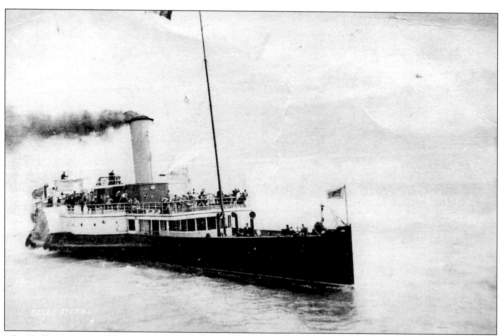

The Belle Steamer. The steamers ran between Yarmouth and London, calling at Lowestoft, Southwold, Felixstowe, Walton-on-the-Naze, Clacton, and Southend. The service was started by the Coast Development Company in 1900.

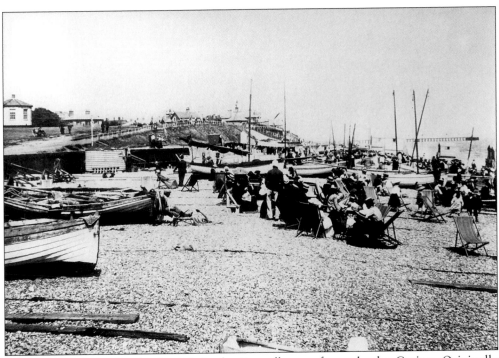

Southwold Beach. On the far left is the Roundhouse, formerly the Casino. Originally a reading room for sailors and later occupied by the coastguards. It is here a ghost, a woman with a shawl over her head, has been seen and described as a 'gentle and reassuring apparition'.

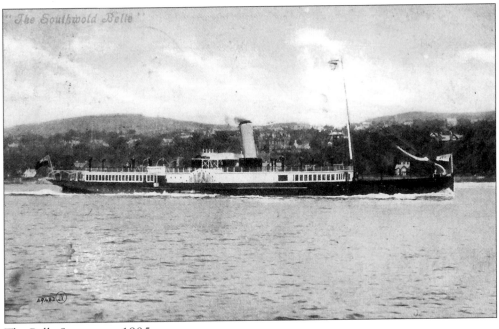

The Belle Steamer, *c.* 1905.

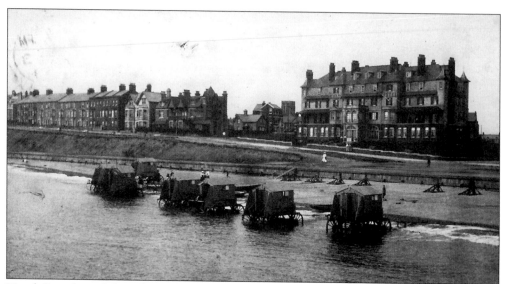

North Parade and Grand Hotel, Southwold, with bathing machines, *c.* 1907.

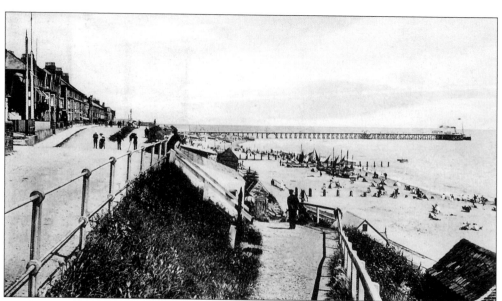

Beach Approach, Southwold.

Seven

People and Occasions

'So gently shuts the eye of day;
So dies a wave along the shore.'

Anne Laetitia Barbauld

Will Edwards's concert party, Lowestoft 1909.

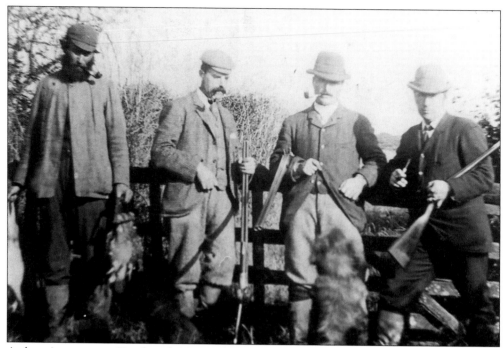

A shooting party at Reydon, 26 December 1891.

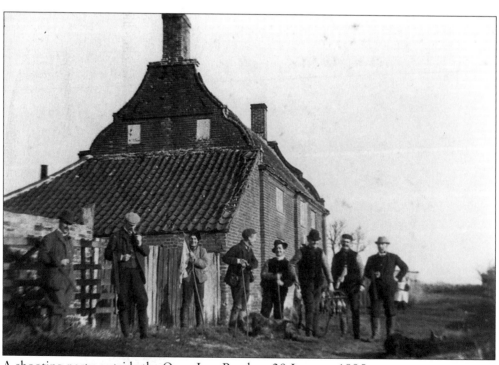

A shooting party outside the Quay Inn, Reydon, 20 January 1895.

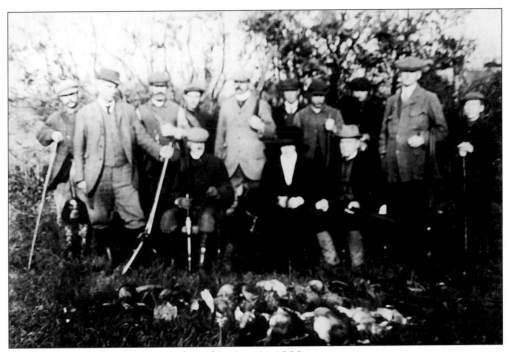

Another shooting party at Reydon, this time in 1900.

The Lowestoft Lifeboat coxwain Robert
Hook (1828-1911). While he was the
leader of the crews, more than 600 lives
were saved.

William Stannard, longshore fisherman, at his cottage in Childs Opening, Southwold. Mr Stannard was a coxwain at Southwold. Both Mr and Mrs Stannard frequently saw a ghost here, a man sitting in a bath-chair wearing a billycock hat. On other occasions the apparition was sighted without the chair, but moving across the yard and through a bricked-up doorway.

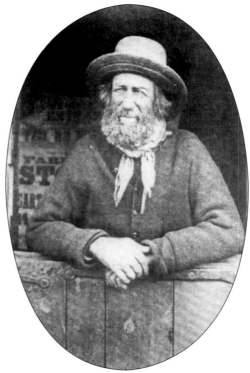

Mr Todd, the Southwold ferryman.

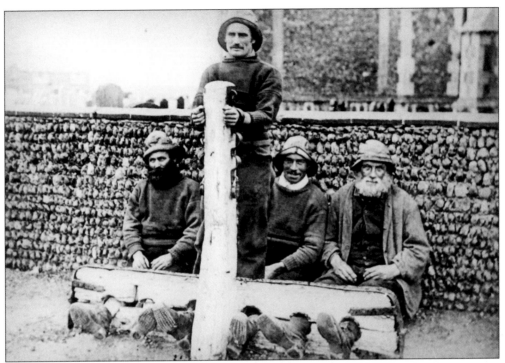

Southwold fishermen. Note their stout hob-nailed boots.

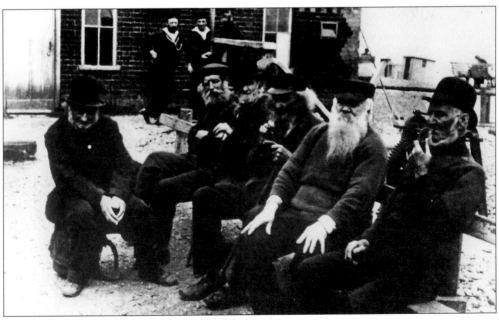

Coastguards and fishermen of Southwold in 1890.

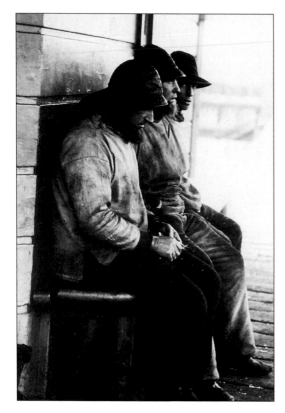

Lowestoft fishermen, *c.* 1900. 'Wet and cold cannot make them shrink nor stain whom the North Sea has dyed in grain.'

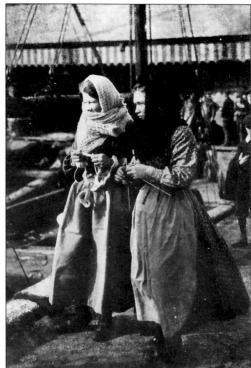

Scots girls at Lowestoft. The girls from Scotland arrived in shawls and long skirts, they were strong, healthy, and cheerful. When they were not working with the fish they were knitting, 'Walking and talking but always knitting.'

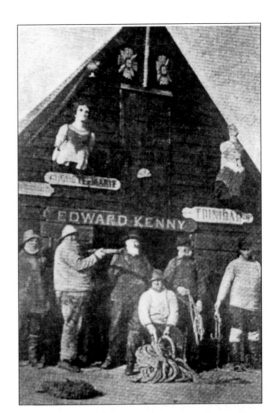

The headquarters of the Old Company of Lowestoft Beachmen. Beachmen were skilled seamen who assisted shipping in several ways. There were three beachmen companies at one time in Lowestoft and they often drove hard bargains. Note the ships' figureheads on this hut.

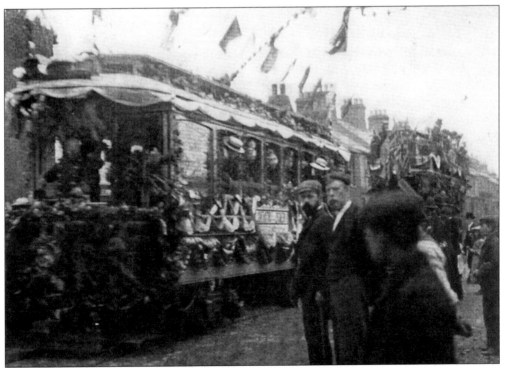

The first trams at Lowestoft in 1903, decorated for the occasion.

George Button, norsel maker and twine spinner of Southwold. There were two rope walks in Southwold, at Field Stile Road and at Cumberland Road.

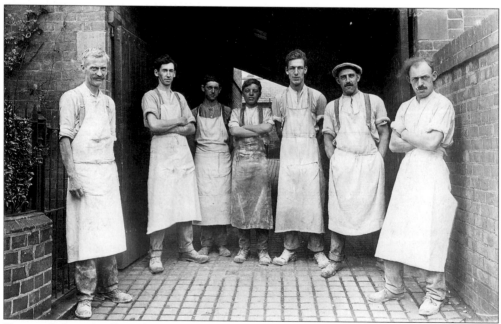

Turners Bakery Staff, Oxford Street, Lowestoft.

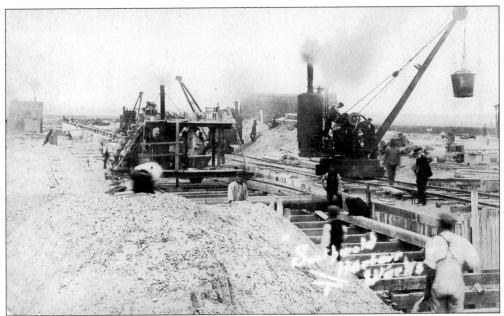

Southwold Harbour Works. Work was started in 1906. The government gave grants totalling £21,500. This was at the time that herring fishing was very prosperous and with the large amount of Scottish drifters (1,000 or more), Lowestoft and Yarmouth had become very congested. It was days before some boats could get to sea and then they also had great difficulty discharging. Southwold harbour was to be improved to relieve the pressure.

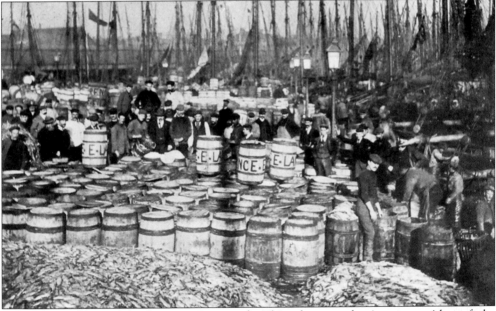

The fish market and harbour at Lowestoft. This photograph gives some idea of the congestion. It was said that it was possible to walk across the harbour by stepping from one boat to another. It must have taken great skill to pack all the boats into the harbour, almost as tightly as the herrings being packed into the barrels.

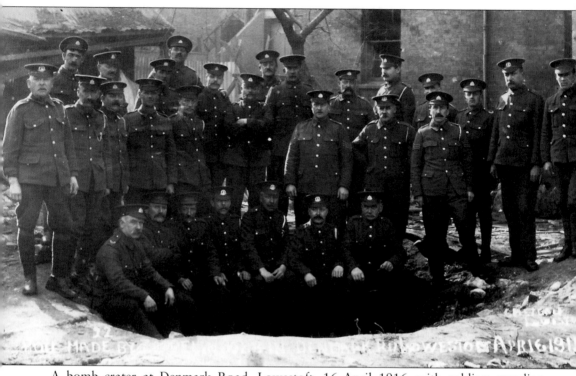

A bomb crater at Denmark Road, Lowestoft, 16 April 1916, with soldiers standing behind.

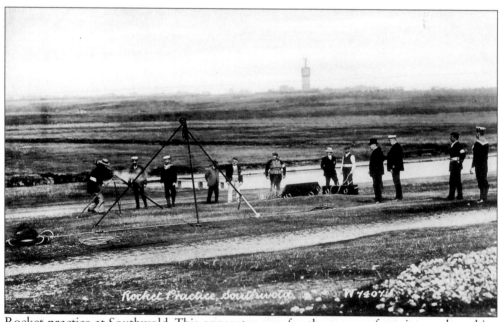

Rocket practice at Southwold. This apparatus was for the rescue of mariners when ships were wrecked near the seashore. The rocket was fired over the wreck, carrying a small line to which was attached a heavier line. Hopefully the crew would catch the small line and the rest of the apparatus, which included a breeches buoy by which the mariners could escape one by one. It was under the control of the coastguards.

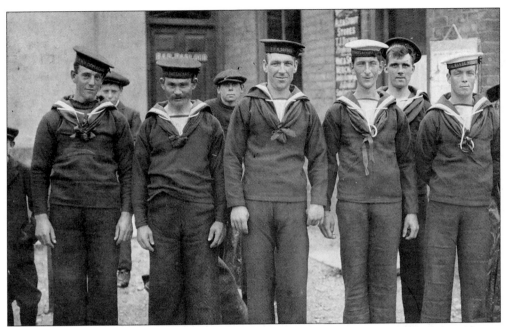

Southwold Naval Reserves off to war on 2 August 1914. Nearly all these Southwold men were drowned. 'Never a battle on the sea but Suffolk was in it . . .' (Julian Tennyson).

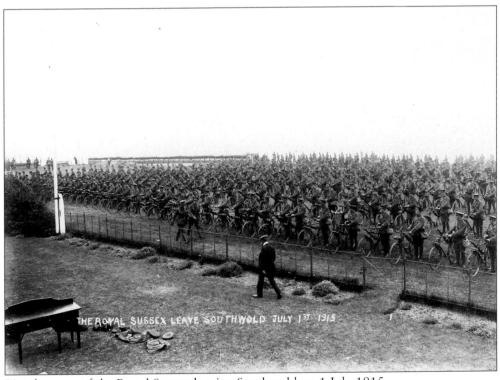

THE ROYAL SUSSEX LEAVE SOUTHWOLD JULY 1ST 1915

Bicycle corps of the Royal Sussex leaving Southwold on 1 July 1915.

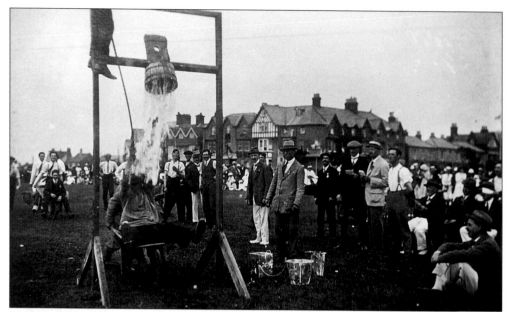

Peace celebrations at Southwold after the First World War. William Henry Tooke is standing almost immediately behind the third bucket from the left. On his left, wearing a cap, breeches and leggings, is Herbert Adair Adnams who, on another occasion, stood up for the rights of the fairmen when some Southwold residents tried to prevent their entry to Buss Creek. 'They have the right', he insisted, 'to come in.' (see page 124).

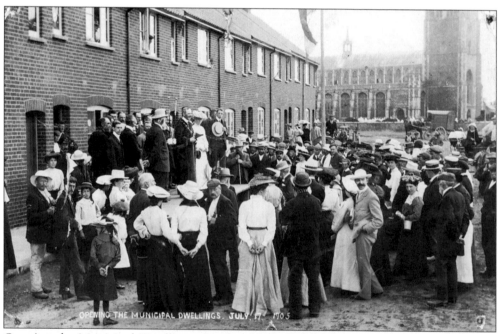

Opening the Municipal Dwellings, Southwold, on 17 July 1905. The first Corporation houses, fifteen in total, were situated in St Edmund's Road.

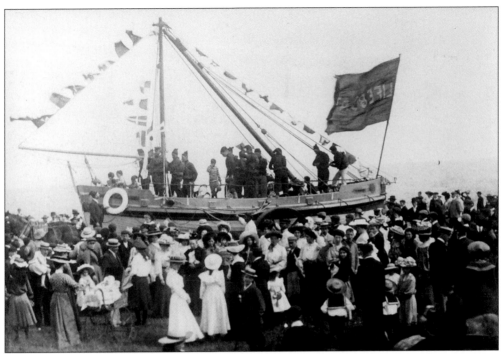

Launching the Lifeboat at Southwold.

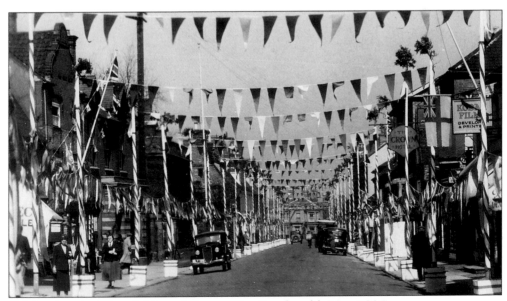

Celebrating the Silver Jubilee of George V at Southwold, May 1935.

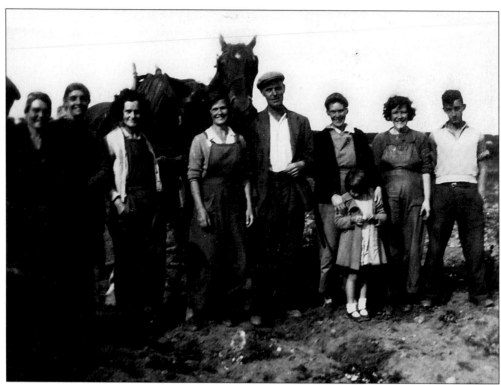

Workers at Smears Farm, Reydon, during the Second World War. Left to right: Ellen Moyse, Lucy Gerrell, unknown, unknown, Jimmy Bullard, Amy McMillan, Patty Cooke, unknown.

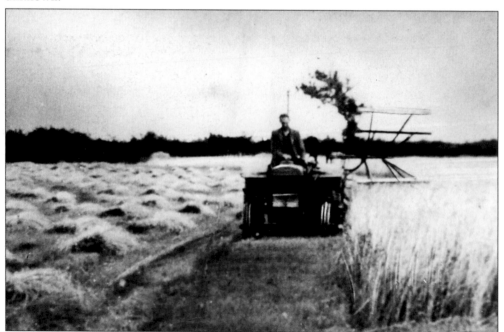

Fred Watson harvesting with a binder and a Fordson Standard tractor at Reydon in 1948.

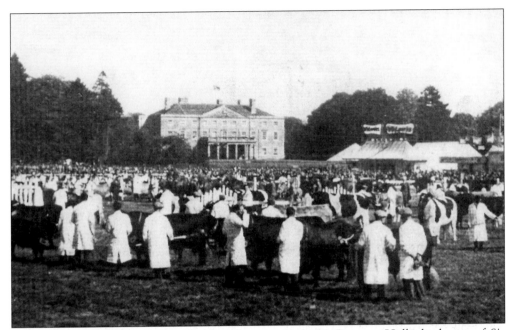

The Suffolk Agricultural Show held at Benacre in 1955. Benacre Hall, the home of Sir Robert Gooch, can be seen in the background. The cattle in the foreground are Red Poll cattle. The first show was held at Wickham Market in 1832.

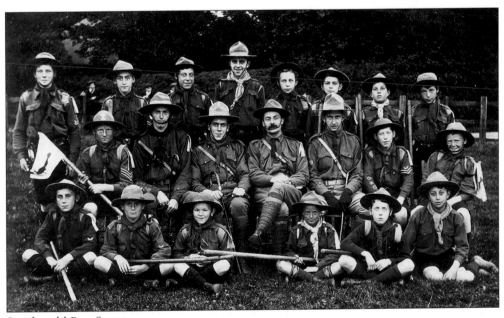

Southwold Boy Scouts.

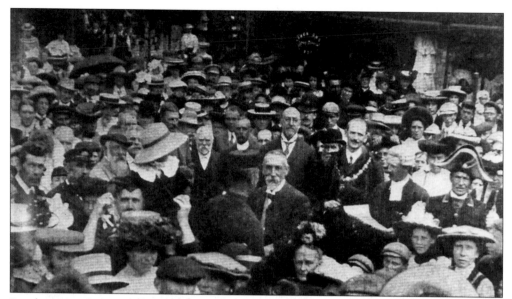

Proclamation being read at the opening of Trinity Fair in the Market Place, Southwold, in 1905: 'Know all persons, present and to come, that the Mayor, Aldermen and Burgesses of the Borough of Southwold in virtue of the several powers, rights and privileges given, granted and confirmed by divers Charters and Letters Patent, of former Kings and Queens of England . . .'

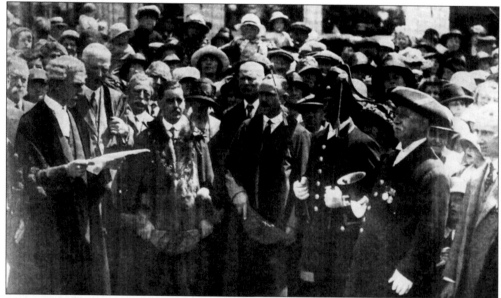

Opening Trinity Fair, 1924. By charter of Henry VII Southwold was granted the right 'to hold yearly and forever' two fairs within the precincts of the town, one to be held for three days immediately following the Holy Trinity. There have been many attempts, all unsuccessful, to abolish the fair. One year certain people of Southwold barricaded the bridge at Buss Creek to stop the Fairmen coming in (they had to enter by a certain time to be legal). Mr H. A. Adnams said they had the right to come in and told Mr Stocks, the fair owner, to hitch his traction engine to the barricades if they were not moved. The barriers were removed.

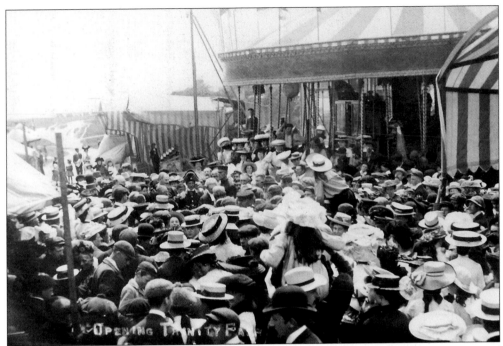

Trinity Fair on South Green, Southwold. One hundred years ago the Corporation passed a resolution that the fair should be held near the Salt Works. The showmen ignored the order and held the fair as usual on South Green. Next year, aided by the Police, the Corporation had its way but the burgesses ensured that the fair afterwards returned to South Green. Since 1922, however, it has been the custom for the Mayor, members of the Council and officials to take the first ride on the roundabouts.

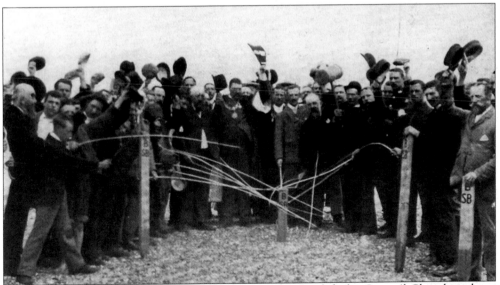

Beating the Bounds at Southwold, 1897. 'The procession left the Council Chamber about noon; passed over East Green, went down the score on the Cliff . . . over the beach to the edge of the sea . . .'. A four and a half mile route with bounds encroached only by a hungry sea.

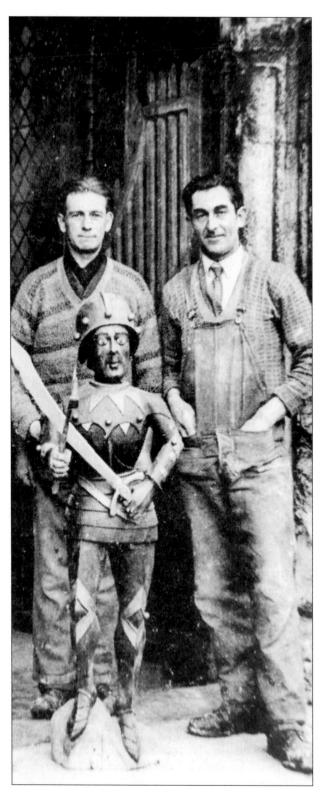

Southwold Jack with friends, 1928. Jack was taken down from his perch in order to be cleaned. Jack, who is made of wood, is a Jack-in-Armour at the time of the Wars of the Roses. In his left hand he has a sword and in his right hand a battle axe which, when pulled by a cord, strikes a bell. The bell is struck before a service and when a bride is about to enter the church. He normally stands in the church and at various periods he stood in the Tower under the West arch, at the Chancel, at the top of the stairway and then over looking the font. Adnams Brewery adopted Jack as its trademark and a replica made of fibreglass stands outside the Brewery offices.

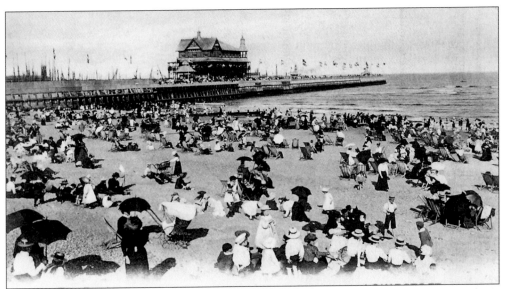

Holiday-time on Lowestoft Beach. Edward Fitzgerald used to wander along the shore after dark, 'longing for some fellow to accost me who might give some promise of filling up a very vacant place in my heart.'

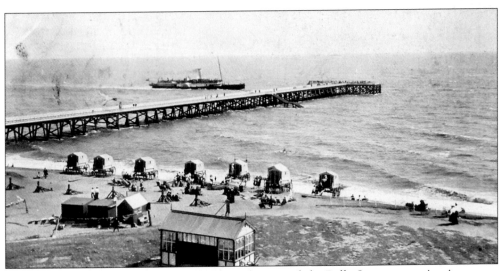

Southwold beach and pier and bathing machines and the Belle Steamer coming in, *c.* 1902.

Picture Credits

The photographs are from the collections of
D. Moyes, D. Neave, P. Kett, J. Tooke, B. Wright, and H. Phelps.